PEONIES & POMEGRANATES

櫻狩

むさしのまくら
梅かう
それなら
子ろ哥るん
やそその花を
枕もとにく
尾張名古屋
秀材

一桑

むさしまくら
なりき尻
新もかうして
梅ーうて
ふのとうく
子ろ花
たむ

むさしまくら
たきおとて
嗣たうえん
さうつ猫
あうてう
きいをを
うにほたえ
挺涼る序
武女

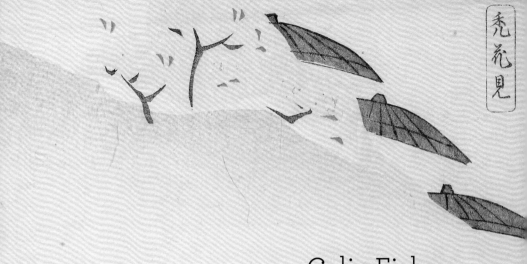

秃花見

Celia Fisher

Peonies &
Pomegranates

Botanic Illustrations from Asia

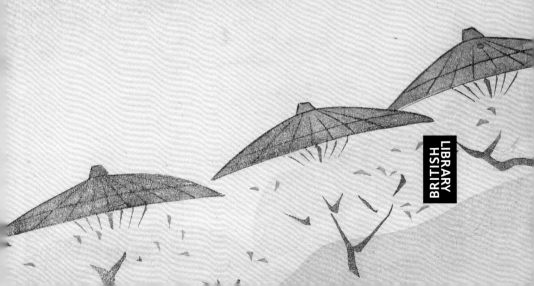

BRITISH LIBRARY

To my daughter-in-law Yu Lin

First published in 2018 by
The British Library
96 Euston Road
London NW1 2DB

Cataloguing in Publication Data
A catalogue record for this publication
is available from The British Library

ISBN 978 0 7123 0974 5

Designed and typeset by Goldust Design
Printed in China by C&C Offset Printing Co., Ltd.

CONTENTS

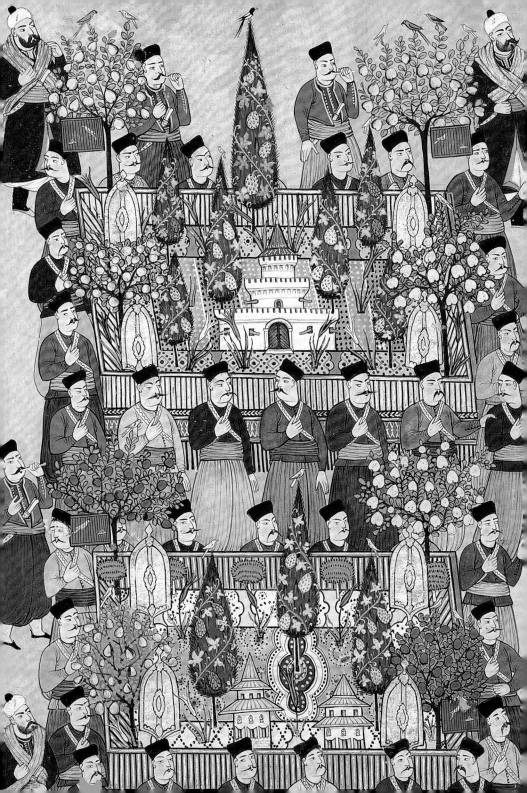

Introduction:
The Garden Setting

The idea of a garden includes many possibilities, but there must always be plants, even if they are taken for granted in the descriptions, or confined to a list. Here they are centre stage: the flowers, fruits and trees most often featured in oriental gardens, depicted by Asian artists and described in their literature, together with some other plants more valued for their uses than their beauty. Gardens provide a *mise en scène* and also help to endow the plants with extra layers of significance.

Collecting and ritualising plants may have begun in prehistoric times. In the Shanidar caves, a Neanderthal burial site in the Zagros mountains, one skeleton appeared to have been adorned with a garland of healing plants including hollyhocks. The rulers of ancient Egypt were also buried with wreaths of leaves and flowers – papyrus, willow, olive, cornflower, pomegranate, blue lotus and anthemis – and garden scenes were painted on the walls of Egyptian tombs. In the temple of Karnak, one room created by the pharaoh Thutmose III (in the fifteenth century BC) was carved with reliefs of plants, including some collected during his campaigns in Syria, inscribed 'all the plants that grow in the Divine Lands'. A few are recognisable: pomegranate and blue lotus again, and also arums, poppies and irises. His predecessor and regent, the female pharaoh Hatshepsut, decorated her temple walls with

scenes from an expedition she sent to the Land of Punt on the Red Sea to collect the *Commiphora* trees that yield frankincense and myrrh. The rulers of Mesopotamia (ancient Iraq) also collected plants throughout their empires and used them to adorn their gardens. An inscription of Ashurnasirpal II (from the ninth century BC) claimed that he dug a canal through a mountain so that the water gushed from above into the garden, which was planted with trees and plants from the countries through which his armies marched: pine, cypress, juniper, almond, date, olive, pomegranate, pear, quince, fig, grapevine.

Later, the legendary Hanging Gardens of Babylon were created, actually in Nineveh, where Sennacherib (704–681 BC) raised a series of galleried terraces like an amphitheatre above a lake, its water brought by aqueduct from the mountains and carried by screw pumps up the terraces. Sennacherib's inscription referred to the clay moulds from which the screw pumps were made in order to draw up water all day long, making the raised gardens 'a wonder for all people'.

In China, the first recorded imperial garden, the Shanglin Park in Xian, was created by the first emperor, Qin Shihuangdi (259–210 BC), who built the Great Wall. He had an Upper Grove Garden raised artificially high above the surrounding countryside to instil awe. The garden reflected the empire itself and contained its plants, including exotics brought as tribute (peaches, grapes and lychees).

Have you not heard of the Shanglin Park of the Son of Heaven
Eight rivers coursing onward, pouring through the chasms
Winding through the forests and across the broad meadows
Their banks covered with green orchids, magnolia, iris and ginger
Breathing forth their fragrance.

Here grow citrons with fruit ripening in summer, tangerines, oranges and limes
Peaches and grapes, mountain plums and lychees
Shading the quarters of the palace ladies. (Sima Xiangru 179–117 BC)

This grandiose tradition continued down the centuries, and first came to the notice of the West when Marco Polo described Shangdu, the summer palace built by Khubilai Khan (1215–1294), north of Beijing. A great lake fed by rivers had been dug out, and an artificial hill formed, as the perfect setting for the emperor's collection of rare trees.

Wherever the Khan received information of a handsome tree growing in any place he caused it to be dug up and had it transported by means of elephants to this mount and added it to the verdant collection. The mount itself, the trees and buildings, form a wonderful sight.

In 1793 Lord Macartney added the final touches to a similar scene, when he described his embassy to the Qianlong emperor. He visited the summer palace at Chengdu with its enchanting pavilions and landscaped settings – 'sometimes a rivulet gently stealing through the glade, at others a cataract tumbling from above, raging with foam and rebounding with a thousand echoes from below' – a description that surely inspired Lord Macartney's contemporary, Samuel Taylor Coleridge, when he wrote his famous poem *Xanadu*.

If, all across Asia, imperial gardens were designed to impress, the spiritual dimensions which they expressed were equally important and probably more ancient. The Chinese had a great

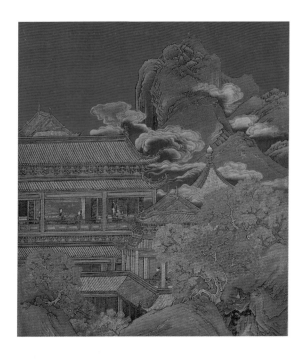

reverence for nature's own harmonies and believed that,
although landscapes could be improved upon and adapted
for human needs, the flowing shapes of rocks, water and trees
provided the vital energies and rhythms of nature that refreshed
the senses and inspired the mind. This was enshrined in Daoism,
which was more a way of life than a religion, though it spawned
the concept of immortals who, having achieved a perfect balance,
lived forever. Even in the Far East the domain of the immortals
was believed to be further east, located on three islands from
which none returned. Thus islands built in an imperial lake,
awash with lotus flowers and ideal for boating, still reflected this
concept, as did three ornate rocks carefully placed in a scholar's
garden pool or, in Japan, the strip of gravel raked in undulating
patterns with moss-laden stones at perfect intervals. Shinto,

the original Japanese religion, had first designated *niwa*, meaning an earthen space arranged and purified to worship the gods, with a wooden *tori* (gateway) as a sacred portal. When Buddhism arrived in the sixth century AD, the practices of meditation to achieve enlightenment fitted readily into the existing ideas of sacred, tranquil places. The life and preaching of Buddha himself was often located in the shade of sacred trees, and naturally Buddhist temples and monasteries had garden settings, with splendid trees framing the views and lovely flowers lining the pathways and plucked as offerings for the images.

In India, Buddha's homeland, the links between gardens and religion were more overtly based on fertility. The Hindu gods danced, revelled and made love in surroundings grown lush

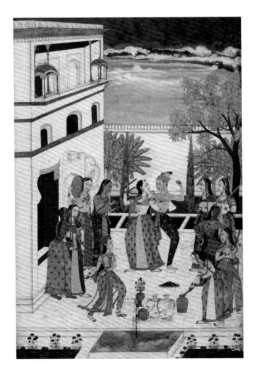

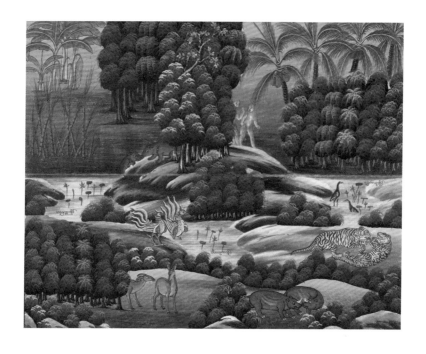

through their actions. The loveliest garden paintings (see p. 11)
showed Krishna and Radha, his consort, surrounded by greenery,
music and birdsong, or Krishna in a circle of *gopis* (female
cowherds), where each girl believed the god was dancing for her.
The austerities of Buddhism did not dispel this love of nature in
full bloom; the concept of an earthly paradise was too strong
not to become part of Buddhist mythology in the lands where
it was adopted. The Burmese Himavanta (above), for instance,
was envisaged as a heavenly forest, its trees heavy with blossom,
surrounding a lotus lake where animals and benign spirits disported.

The word 'paradise' is of Persian origin. It simply means
'enclosure', but one in which there would be shade, greenery
and water, all doubly precious in a hot and barren landscape,
where an oasis in the desert was the archetypal image of hope and

blessing. The Christian concept of Eden had a similar birthplace in the Old Testament book of Genesis: 'and the Lord God planted a garden eastward in Eden. In it was every tree pleasing to the sight and good for food, and a river flowed through the garden, dividing it into four'. The concept of a fourfold division became more geometric in Islam (the Ka'ba, the holiest site in Mecca, is a mystic cube, symbol of perfection) and the gardens of the blessed 'underneath which rivers flow' were described in the Koran as 'four gardens in two pairs'. The water channels that gave the garden its symmetry flowed from a central pool, ideally with a fountain. The pool was often octagonal, and the four basic rectangles could also be multiplied, but it remained the *chaharbagh,* the fourfold garden. The trees specified in the Koran were palms and acacias, with grapevines, but the Persian miniatures which are the best visual record of Islamic gardens show other pairings, such as tall evergreen cypresses contrasted with graceful willows or blossom trees. The latter may be an example of Chinese influence, as were the red chinoiserie fences and gateways. The finest shade trees were the oriental planes, depicted with autumnal colours on the leaves. And beneath them in the four quarters were bright carpets of flowers: narcissi, hyacinths, tulips and violets, followed by irises, lilies, poppies, marigolds, jasmine and the roses of the *gulistan*, or rose garden. Within the formality, the sensual pleasures of sight and smell, accompanied by birdsong and the trickle of water, were most treasured.

Planes, cypresses and blossoming fruit trees are also the trees that appear in stylised form on oriental carpets, which all originated as nomadic prayer rugs – representing a sacred space that could easily be transported and turned towards Mecca. The rugs bore other symbols of the paradise garden: the enclosing

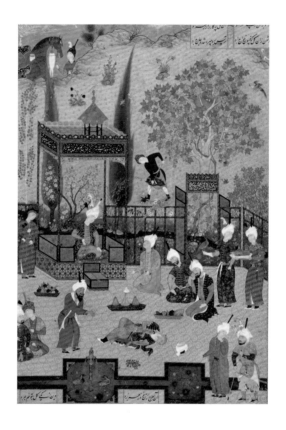

borders; the *guls* of the rose garden; and in certain garden
carpets even the water channels, with fish, as well as many
flowers. Nomadism was at the heart of it, all across Asia: not
just the herdsmen, or the merchants yearning for home, but also
the conquering rulers, from the Mongol tribes who constantly
threatened China and occasionally formed ruling dynasties, to the
Turkic hordes who drove further west, overwhelming the Persian
Empire, establishing themselves as the Mughal rulers of India and
finally reaching a Turkish homeland centred on Istanbul. As they
adopted the ways of the civilisations they conquered, making cities
their strongholds, they surrounded the outskirts with gardens in

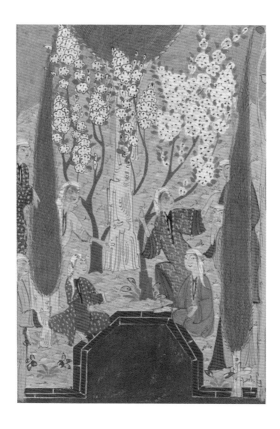

which to enthrone themselves, turning their tents into canopies and pavilions. The miniatures their court artists painted often retained the atmosphere of an encampment in the meadows, or a starlit feast after a successful campaign.

The Mongol warlord Timur, often known as Tamberlane (1336–1405), created no fewer than five gardens around Samarkand, including the Garden of Heart's Delight and the Garden of the Plane Trees. These were described by the Spanish ambassador Gonzáles de Clavijo, who visited his court from 1403 to 1406, as large areas with tents, some of red cloth, others of embroidered silk, set under the shade of all kinds of fruit trees, with channels of

water flowing among them, and great numbers of people enjoying themselves near the fountains. When Timur's descendants founded the Safavid dynasty in sixteenth-century Persia they followed suit. Shah Tahmasp transferred the capital from Tabriz to Qazvin and made it a garden city or *baghistan*, celebrated by his court poet 'Abdī Shīrazī (known as Navidi) as symbolic of the Shah's power, his patronage of the arts and his lordship of the harem. According to Navidi, the garden was reached by a processional way, flanked by tall walls and water channels lined with plane and mulberry trees, leading into the enclosed royal garden. The main walks divided it into four, with a grid of subsidiary ways forming fourteen plots with vineyards, orchards, and flower and rose gardens, where 'varieties of fruits have ripened / Hundreds of kinds of flowers have sprung up on every side ... Yellow, many-petalled rosebushes smile'. In 1587, when Shah Abbas succeeded to the throne after a troubled period, the heads of twenty-two of his enemies were speared above the garden walls overlooking the bazaar, thus reasserting the garden as the centre of royal power; but also of relaxation, as Shah Abbas confirmed when he enclosed a plot of land chanced upon while hunting, full of water and water birds. Here he ordered himself a bird hide, planted lilies, marigolds and wild carnations, and called it the Pleasure Corner of the Shah. Later he made Isfahan his capital and the loveliest *baghistan* of all, with the Abode of Felicity at its centre, where the courtyards, rose gardens and nightingales were celebrated by his court poets.

In India, Babur (1483–1530), another of Timur's descendants and the founder of the Mughal dynasty, inherited the same tradition of establishing gardens wherever he gained power, passing the concept to his successors, and influencing the

neighbouring Rajput princes. Babur's first love always remained the Bagh-e wafa (Garden of Fidelity) in Kabul (below), surrounded by pomegranates and other fruit trees, and carpeted with bright flowerbeds. But as a nomadic warlord he followed dynastic precedents, celebrating the birth of his first son Humayan, in Herat, by holding a feast in a garden. In Samarkand he made sure to visit the tulip meadows in springtime. When he captured Delhi in 1526 he was immediately intrigued by the exotic plants of Hindustan and disgusted by the lack of running water, or any sense of the necessary symmetry in gardens.

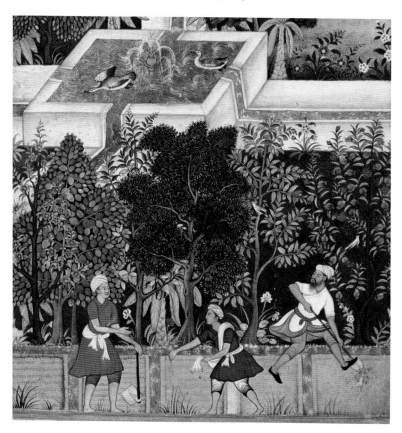

Alongside his accounts of military campaigns he listed plants, and detailed how to improve irrigation systems, experimenting with the various designs of waterwheels that he encountered. Mangoes were the new Indian fruit he most relished. Within days of establishing his new capital at Agra he chose a site for a new garden (unpromising at first) and by the following spring the area was walled, with an octagonal pool around which narcissi and then roses flowered. Indian plants were added later, especially the red oleanders of Gwalior. The fourfold division of the *chaharbagh* remained central to the Mughal garden, but beyond it there was an opening up to the natural landscape, and the narrow water rills widened into canals and then great tanks, once their cooling effect was appreciated. After Babur's grandson Akbar annexed Kashmir in 1586, a fresh lushness invaded Mughal gardens. Rhododendrons entered the scene. Akbar's successor Jahangir, though his movements remained peripatetic, centred his favourite new gardens on terraces above Lake Dal with its lotuses. 'Kashmir,' wrote Jahangir, 'is a garden of eternal spring ... the wind fans the lamps of the roses.' Like his great-grandfather Babur, he evaluated the fruits, including cherries, apricots, pears, apples, guavas and pomegranates, and concluded his list by saying 'there are mulberries everywhere looped with grapevines'. But it was in Agra that Jahangir grew his most exotic fruit, 'the extremely good smelling and tasting' pineapple, introduced from Central America via the Portuguese in Goa. The same provenance was shared by the *Tagetes* marigolds, which had achieved improbable popularity in Indian gardens. Naturally the gardening enthusiasm of the Mughals was infectious among neighbouring Indian rulers, who also relished having themselves and their Hindu gods depicted in fertile surroundings.

18

Akbar caused the memoirs of Babur, the *Baburnama*, to be produced as a wondrously illustrated manuscript in the Persian style. Besides the main pictures of Babur himself in action, there were subsidiary illustrations of the trees and shrubs of his domains, and golden borders with floral embellishments – lilies, tulips, irises and poppies. It was Akbar's son Jahangir, however, who first had an album painted with full-page illustrations devoted to his favourite flowers (and the contents of his zoo). His court artist was Ustad Mansur, who included the red tulip of Kashmir, *Tulipa lanata* (as well as a zebra, a dodo and a turkey). Jahangir's grandson Dara Shikoh, oldest son of Shah Jehan, possessed a similar love of plants and a similar album, which fortunately survived when his austere brother Aurangzeb seized power and murdered him.

In the poetry inspired by Persian and Mughal gardens, the allusions tended to rely on favoured traditions – flowerbeds were as colourful as peacock feathers, reflections in water doubled the pleasure, the nightingale sang as the rose unfurled its petals, a hibiscus bloomed all year unlike the inconstant rose, tulips burned like lamps, the hyacinth resembled the tresses of a beloved woman, and the narcissus was drunk. Chinese poets and literati also relished quoting their forebears – the scent of orchids under the hedgerows, dew like tears on magnolia petals, peonies like silken cushions, plum blossom whirling in the snowflakes. The melancholy of a provincial governor serving far from home, or exiled, lurked in the autumn rain as it dripped from the eaves of garden pavilions and the tips of bamboo leaves. In seventeenth-century Japan, the monk Basho followed another poetic tradition by creating verses limited to a strict form of lines and syllables. His haiku were usually allusive, and he went on pilgrimages to

sites where former poets had described a particular tree, but he also had a wonderful power to startle: 'It looked as if irises / had bloomed on my feet / my sandals laced in blue'; 'From the hairy recesses of a peony / filled with sweetness / a bee creeps'.

An intense appreciation of individual flowers and trees was first expressed in China – small wonder, since they have nature's richest plant diversity set in landscapes of exceptional variety and beauty. The ancient Songs of Chu (which have no date) set the literary tradition of poetic references to plants, while Confucius's sayings were identified with apricot blossom since he taught his students in an orchard. Although descriptions of imperial gardens were breathtaking, the gardens of the scholar classes, which were on a much smaller scale, with carefully positioned plants rich in meaning, became the archetype. They are exemplified still by the

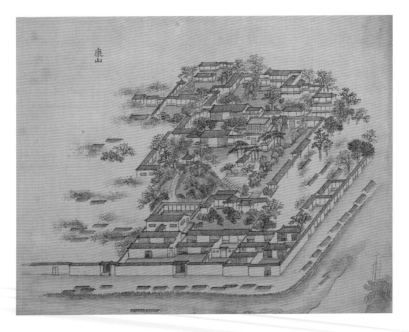

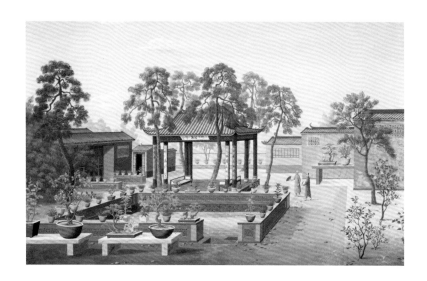

gardens of Suzhou – the Garden of the Humble Administrator,
or the Garden of the Master of the Fishing Nets. And even
emperors would enjoy retreating to a small Garden of Harmonious
Interest, with a pavilion set aside for quiet intellectual pursuits.
This was how fine calligraphy, a skill acquired even by emperors,
but owing its status to scholarly practice, became central to
gardens. This was either in the form of evocative quotations
carved onto rocks – for instance, 'a distant view of hills' would
reference chrysanthemums because of the poems of Tao Qian
(378–427) – or the planting of bamboo against a white wall,
where the shadows of the leaves would look like dancing
brushstrokes. Perfection could be achieved on a small scale;
it fitted the ethos, since all gardens were considered landscapes in
miniature. If one had no room for a lotus pond with goldfish, a large
blue and white ceramic bowl would contain a charming alternative,
and a mountain pine could be miniaturised as *pen zai* (the origin
of Japanese bonsai) in a choice of styles: upright, cliff-hanging,

twisting trunk or exposed root. For the Chinese, putting plants in pots can be dated back 7,000 years, according to the archaeological evidence of two potsherds with intaglio designs of potted plants found in Zhejiang province. In the different seasons it was always the practice to fetch out, or buy, particular flowers and display them for a spell in the most prominent place. The Tang dynasty poet Bai Juyi (772–846) described the peony markets of Xian:

Spring comes late in the capital
Noisy chariots and horses are passing
In the street peony sellers call out
And everyone comes to buy flowers
Hundreds shine bright red
There is a bouquet white as crystal
Here are the old colours but changed
Every house buys them according to custom.

The most popular description of a Chinese garden is in Cao Xueqin's eighteenth-century novel *Dream of the Red Chamber*, set in Nanjing (where depictions of the porcelain pagoda so influenced European chinoiserie). At its entrance, the garden in the story is hidden by a screen of rugged white rocks dappled with moss and creepers. A narrow zigzag path leads between them into a ravine green with magnificent trees and rare flowers; a double-flowered peach blossom is mentioned. A clear stream winds towards a pavilion overlooking a pool and a bridge. Beyond, a wall with a circular moon gate and climbing plants both conceals and reveals the next part of the garden. A character remarks how boring it would be if visitors could see the whole garden as soon as they entered. Here again, the finishing touches are the poetic

quotations inscribed on rocks and lintels, because otherwise 'the garden, however lovely with its flowers and willows, rocks and streams, cannot fully reveal its charm'.

Japanese gardens also had a venerable literary heritage, especially in two astonishing works written around AD 1000 by women of the Heian court, both revealing how fashionable it was to appreciate flowers. *The Tale of Genji*, in which the hero is the emperor's son but not his heir, unfolds with delicate melancholy in a series of liaisons, often set in gardens with ladies named after flowers. They sit behind paper screens, alongside raised verandahs, as their lovers approach through the garden, over the stepping stones of the stream where the irises grow, past the bamboos and the twisted pines, reaching the verandah which is swathed in creepers, where they pause to pluck a significant flower. Various chapters are named: The Paulownia Court; The Festival of Cherry Blossoms; An Autumn Excursion to View Red Leaves; The Village of Falling Flowers; Morning Glory; Evening Glory; and many more. But, above all other flowers, wisteria is the leitmotif of the book, and the garden Prince Genji designs for his future wife Murasaki is festooned with it.

The Pillow Book of Sei Shonagon is more like a journal, colourful and opinionated. Sometimes she writes lists, for instance of Elegant or Splendid Things, which include: 'a large garden covered in snow. Anything purple, be it flowers, thread or paper. Among purple flowers however I do not like the iris despite its gorgeous colour'. Or she makes lists of flowers and trees, beginning: 'Hollyhock is a most delightful flower. To think that ever since the age of the gods people have been decorating their hair with it at festival time'. Sometimes there are accounts of festive days: 'On the ninth day of the ninth month there should

be a drizzle from early dawn, then there will be a heavy dew on the chrysanthemums.' Or court gatherings: 'As I looked at all the men gathered there with their fans, I had the impression that I was seeing a field of pinks in full bloom.'

A little later in the eleventh century the oldest garden manual was written by a Japanese author from the same aristocratic circles – Tachibana Toshitsuna's *Sakuteiki* (Notes on Making Gardens). This genre continued to appear, imparting rarefied information

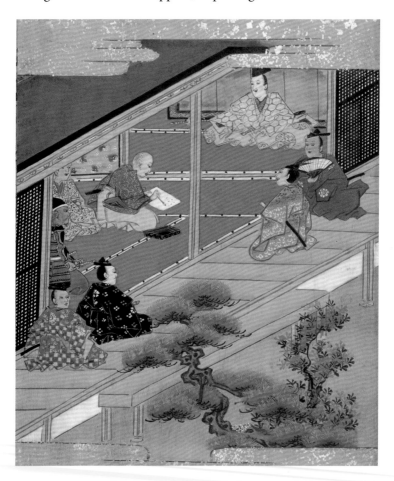

on the correct placement of garden features and plants, until the nineteenth-century Edo period. In *Sakuteiki* the various garden types were Ocean, Mountain Torrent, Broad River, Wetland and Reed; the ethos, integral to Japanese culture, was that visiting sites of great natural beauty was like a pilgrimage, and gardens reproduced the spiritual experience. They did so with increasing artifice, using rock groupings, stone lanterns to illuminate the way, carefully spaced stepping stones and the purifying water scoop. Despite Japan's wealth of lovely plants, trees were confined to focal points and flowers always precisely positioned.

The mysterious heart of the Orient remained concealed for many centuries, although the most useful plants filtered through, like knowledge, to the Mediterranean and Europe: the biblical palm, vine and gourd; fruits known to the Greeks and Romans such as pomegranate, quince, cherries, even oranges; and horticultural skills such as the grafting of apples. There were also textiles such as silk and cotton, dyes such as indigo and scents such as jasmine. The medieval Arab world was the finest repository of medical knowledge, and European herbals owed much to Arabic texts, though few have survived to claim the credit (and here only a poppy carries the flag). Arabic merchants also controlled all land and sea routes to Asia, rendering silks, spices, saffron and sugar rare and expensive. It was not until the Portuguese, hotly pursued by other European nations, found the trade routes round Africa that control began to shift. New products such as tea, and brightly dyed cotton textiles, increased the commercial impetus to open up the East, and imaginations were fired by images such as the Dutch traveller Jan Nieuhof's prints of pagodas, and the flowers on imported wallpaper, fans and teacups. In the early days some of the few Europeans allowed into the Chinese court were Jesuit

missionaries with scientific skills. In 1743 the Jesuit missionary and painter Jean Attiret sent a long description of the imperial gardens of Yuanmingyuan, the Old Summer Palace, which fitted the arguments of fashionable European gardeners that formality should be abandoned for the imitation of natural landscapes:

> *All the risings and hills are sprinkled with trees; and particularly with flowering trees which are here very common ... Pieces of rock ... are placed with so much art that you would take it to be the work of nature. In some parts the water is wide, in other narrow; here it serpentises and then spreads away ... The banks are sprinkled with flowers as if they had been placed there naturally.*

Attiret then described the winding paths that led from one valley to another, to gilded retreats with brightly tiled roofs and names like 'The Sound of the Wind in the Pines' or 'Viewing the Autumn Moon'. William Chambers, who led the fashion for chinoiserie gardens in England with his *Design of Chinese Buildings etc* published in 1757 (and who designed the pagoda at Kew), had been confined like most Europeans to the trading post of Canton (modern Guangzhou). He admitted that the gardens he saw in China were very small, laid out in a succession of courtyards to imitate natural scenes, with carefully placed shrubs, creepers, bamboos and flowerpots 'making a composition, and rendering what in reality is trifling and limited great and considerable in appearance'.

The camellias, peonies, chrysanthemums and orchids, azaleas and wisteria which first reached Europe were potted plants from the nurseries of Canton, and later from other treaty ports such as Shanghai. This was where Robert Fortune made his initial collections in 1842, experiencing like Chambers the

intricacies of small gardens: 'low walls in all directions with lattice or ornamental openings in them … We are led through passages and then the garden with its beautiful flowering shrubs is again opened to the view by glimpses through arches in the wall'.

By the mid-nineteenth century, as a result of the Opium Wars, China was under enormous pressure to open up to trade. This was the time when Fortune became the first plant hunter to breach the interior, setting off in 1848 disguised in Chinese clothes, in search of tea bushes and new flower species. Many followed, and still follow, searching for fresh examples of China's plant wealth. Among them the name of Ernest Henry Wilson stands out. He was collecting early in the twentieth century and discovered new clematis, mecanopsis, magnolias, lilies and peonies. Other plants indigenous both to China and Japan first reached Europe from Japan, even earning the misleading suffix japonica as a result. Although European behaviour in the seventeenth century had caused Japan to expel all foreigners, the port of Dejima off Nagasaki remained a Dutch concession. Here the European botanists Engelbert

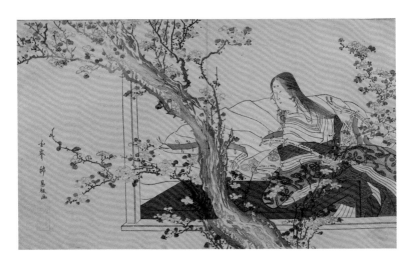

Kaempfer (arriving in 1690), Carl Peter Thunberg (who published *Flora Japonica* in 1784) and Philipp Franz von Siebold (imprisoned and then expelled in 1829), who were officially doctors to the Dutch governor of Dejima, managed to discover and publish an astonishing amount about Japanese plants, partly through links with Japanese medical students, partly on the annual embassy that was allowed to travel to the court at Edo (Tokyo). Siebold especially made many significant plant introductions and also employed Japanese artists to provide a lasting and beautiful record, published in *Flora Japonica* (1835–42).

Meanwhile, in India and South East Asia the European East India Companies succeeded in gaining firmer control of commercial relations, which meant greater opportunities for plant hunting and recording. For instance, the Dutch governor of Malabar on the southwest coast of India, H. A. van Reede tot Draakestein, produced twelve great volumes entitled *Hortus Indicus Malabaricus* (1678–1703), including the first engravings of tropical orchids. In Indonesia George Eberhard Rumpf, who lived in Amboina from 1653 to 1702, produced another twelve volumes called *Herbarium Amboinense* (1741), alongside an illustrator, Pieter de Ruyter, who captured the opulent beauty of tropical flowers such as lotus, erythrina and pitcher plants. Later generations of plant collectors realised the potential of hiring local artists, as Siebold did in Japan, to depict these treasures with a lightness of touch that remained true to oriental traditions. An example is William Roxburgh, who was pre-eminent in investigating Indian plants, especially their commercial attributes, from acacias to cotton and spices. Roxburgh first arrived in India in 1766 as an East India Company doctor stationed in Madras, where he cultivated a garden of economically useful and medicinal plants, and in 1793 was appointed Director of

the recently founded Botanic Garden in Calcutta. His great work *Plants of the Coast of Coromandel* (1795–1819) involved training local artists to combine their natural skills with the necessary scientific observation, so that their botanical art included details of the inner parts and seed cases of flowers. His contemporary, the Governor General of India, Marquess Wellesley (brother of the Duke of Wellington), also used local artists to create his own collection of natural history drawings, as did Thomas Hardwicke, an officer in the East India Company army, who on his return home in 1823 became an influential member of the Royal Society, and displayed his collections in a museum in Lambeth. The most avid patron of all was Sir Thomas Stamford Raffles, Governor of Java (1811–15) and Sumatra (1817–22) and founder of Singapore, who employed a busy workshop of mainly Chinese artists at his residence in Bencoolen, Sumatra, to illustrate the local flora and fauna.

Their brief biographies unfold here alongside the plants with which they were most associated, for this book is mainly about the plants themselves, and about the people of Asia who first collected, appreciated and illustrated them. As Confucius said (according to Ezra Pound, 'Canto XIII'): 'the blossoms of the apricot blow from the east to the west and I have tried to stop them from falling'.

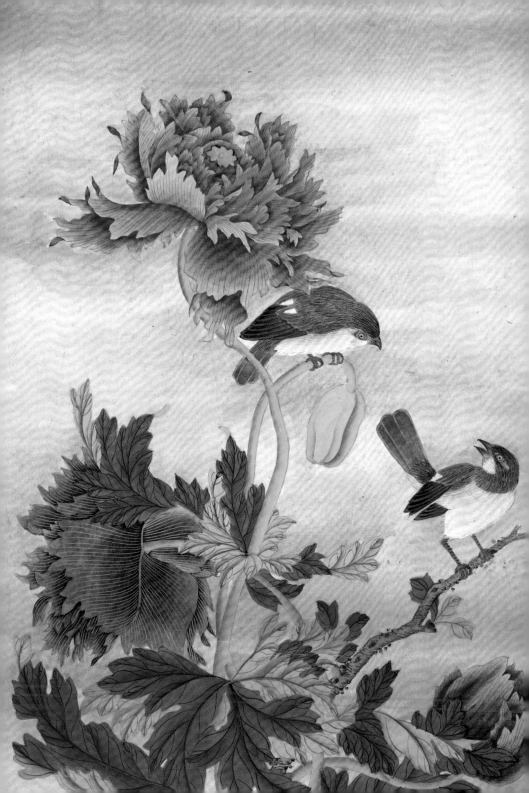

THE PLANTS

Author's Note

The aim of this book is to restore some of the many plants we owe to Asia to their original context. It can only be a few, because there are so many, and on the whole the more familiar have been chosen. Here they are introduced through the descriptions and beliefs of those who knew them first, and the artwork is Asian.

The quotations from Asian literature have been extracted or adapted from a variety of anthologies and secondary sources.

The plants appear alphabetically under their Latin name, with the common English name also shown. Occasionally an indigenous name has been adopted, such as amana; indeed there are very well-known names in many languages, such as tulip and jasmine, that are oriental in origin, like the flowers themselves.

ACACIA

Acacia

The resin from acacia trees had been traded for centuries as gum
arabic before William Roxburgh assessed the qualities of the
various species he discovered in India. Now it is said that true
gum arabic comes from *Acacia senegal*, which supplied Africa
and the trans-Saharan routes. But the gum arabic of Arabia – and
India – was *A. nilotica* (seen here with its distinctive pods), which
was named by Linnaeus from Egyptian specimens. Later it was
discovered that Australia has the world's greatest range of acacias
(named wattles for their fencing uses) and, to distinguish them,
the non-Australian species were renamed *Vachelia*. Roxburgh
and his Indian informants, untroubled by such niceties, detailed
the plant's unrivalled variety of uses, and confirmed *A. nilotica*
as 'the most useful species, abundant over every part of India, in
flower most of the year, and likes poor uncultivated soil'. From the
branches came vital shade, fuel and fodder; the timber provided
boats, wheels, furniture and tools; the gum itself was medicinal,
and in the dyeing process was 'much in use among the chintz
painters' – textiles being a primary product of India. Roxburgh
led the field in recording the uses of Indian plants and publishing
them in his great work, *Plants of the Coast of Coromandel* (1795–
1819), which was much enhanced by the work of the Indian artists
who provided the illustrations.

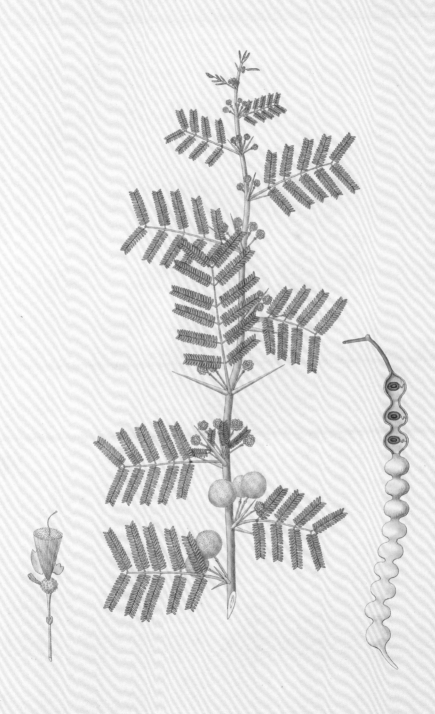

Mimosa arabica

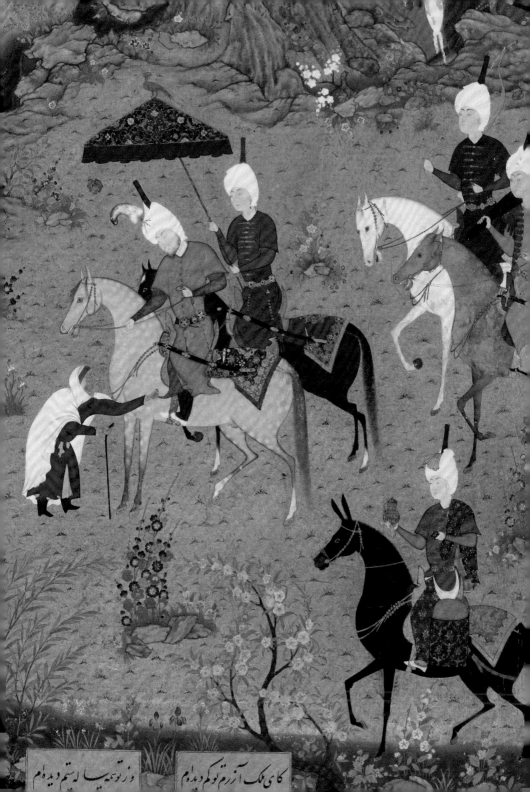

ALCEA

Hollyhock

Though hollyhocks are now characteristic of cottage gardens, they are in fact exotic Asian plants, a fact acknowledged when they reached medieval Europe under the French name *rose d'outremer* (meaning 'overseas', where the Crusades were fought). In their English name, holly is a corruption of holy, meaning a mallow (hoc) from the Holy Land, brought back as seeds by pilgrims or crusaders. When hollyhocks reached China they were called *Jung Kuei*, mallow of the western tribes, and valued for their soothing curative properties, which all mallows have. Meanwhile, in Persian miniatures, hollyhocks appeared everywhere, not only in garden scenes but in the dry and rugged landscapes where armies fought and heroes re-enacted their mythological deeds. Here Sultan Sanjay, a twelfth-century ruler of the Seljuk Turks, is shown being accosted by an old woman who complained that his men had robbed her. Refusing to consider anything so trivial when he was off to conquer the world, he was brought up short by her asking how he could conquer foreigners if he could not control his own soldiers.

Amana

Amana is like a tiny tulip, but whereas most wild tulips grow in the Central Asian uplands, amana grows in water meadows in China, Korea and Japan, considerably further to the east than any other tulip. Certain botanical features also make it different, most noticeably the thin, leaf-like bracts just below the petals, which no tulip has. Although it is not fully accepted as a tulip, it is sometimes called *Tulipa edulis* (meaning 'edible tulip') because, as Philipp Franz von Siebold recorded, the bulbs can be toasted and eaten like chestnuts. Its Japanese name was *amana* and this was adopted by Siebold. Having trained as a doctor in Germany, Siebold was employed by the Dutch East India Company, arriving first in Indonesia and in 1826 continuing on to Dejima, an island off Nagasaki, which was the only European trading post then permitted in Japan. From there, after proving his medical prowess, Siebold joined the annual Dutch embassy to the court at Edo (Tokyo) but his uncontrollable curiosity led to him being expelled as a spy. Back in Europe, amana never caught on commercially like other species of tulips. The pale drooping flower is so tiny, so veined with grey, that perhaps it looks most exquisite on the pages of a Japanese album, surrounded by the calligraphic descriptions of its usefulness.

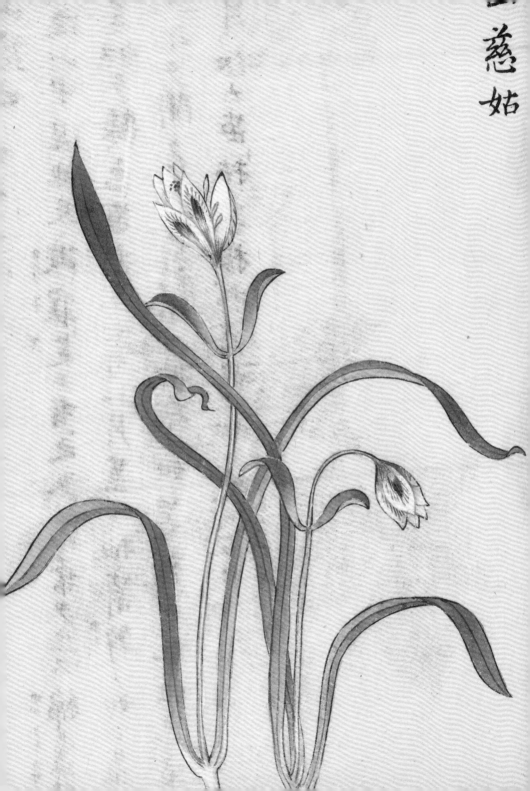

山
慈
姑

Amaranthus

Amaranthus, and the closely related celosia or cockscomb, are very nutritious as well as ornamental. The plants grow readily, indeed like weeds, across South and South East Asia, Central and South America and Africa, providing a leaf vegetable not unlike spinach, and grains that are superior to cereals in their protein, vitamins, folic acid, fibre and minerals. Rather unfairly, in view of all this, they are known as pseudo-cereals. Traditionally they have been harvested from the wild, but in China, India and South America amaranthus is now a widespread and easy crop. It does not degrade the soil, as many crops do, and it may increase in worldwide importance under pressure of population growth and famine. But only in China have celosia, and to a lesser extent their indigenous *Amaranthus cristata* (shown here), been celebrated by generations of artists. The weird clustering flowerheads, variegated leaves and multiplicity of bright colours all challenged the skills of Chinese artists, who were traditionally trained to represent nature with calligraphic brushstrokes.

Amherstia

One of the most spectacular flowers of the Orient, growing on a large tree and producing scimitar-shaped pods, amherstia is also known as the Pride of Burma. Only there is it indigenous (and rare), but it propagates readily enough in the tropics and is now a widespread ornamental. The story of its discovery is characteristic of the European unveiling of the East. It was identified when Nathaniel Wallich, Director of the Calcutta Botanic Garden, first received dried flowers and a description in 1826. He resolved to track it down by accompanying an embassy to Burma (Myanmar) led by General Amherst, Governor of India. Ten years earlier, Amherst had led an embassy to the Qing Emperor of China, which was even more embarrassingly unsuccessful than his predecessor Lord Macartney's had been – except for the botanical discoveries made by members of his entourage. In 1827 Wallich reached Rangoon (Yangon) with Amherst, then went off plant hunting along the River Salween, at last discovering amherstia in the overgrown grounds of a monastery. He described it with rare superlatives, also noting that its blossoms had been gathered and placed before the shrines. He named amherstia, not after the General himself, but his wife and daughter, who were the keener botanists.

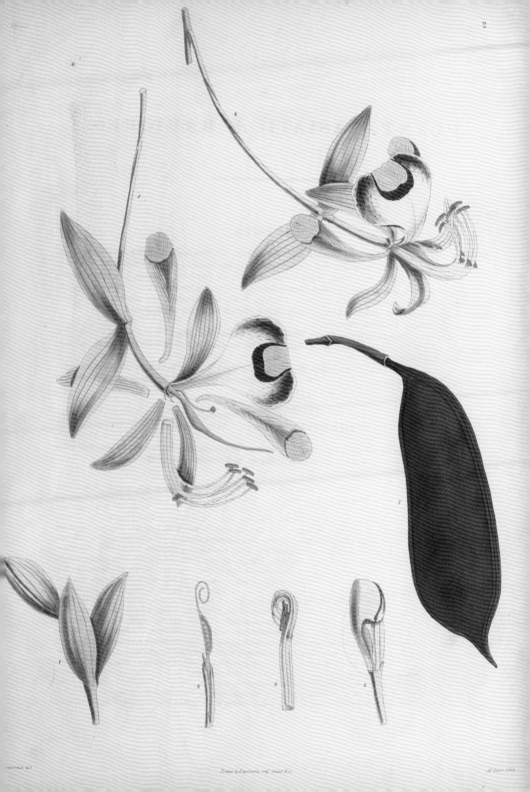

Artemisia

Artemisias are rank wayside plants, with coarse feathery leaves and the most insignificant flowers of the daisy family. But from time immemorial, and worldwide, artemisias have been revered for their aromatic foliage, deemed able to repel everything from fever to worms (hence the name wormwood) and from evil spirits to insects (hence midge or mugwort). Modern chemical research has proved that these beliefs were substantially true, especially in the case of the Chinese species, *Artemisia annua* or sweet wormwood, from which a major anti-malarial drug is now derived. The essential component is artemisinin, which inhibits the malarial parasite from feeding on red blood cells. Artemisia is capable of similar efficacy with other internal parasites, as well as sharing the insect-repellent scent of other members of the *Compositae* or daisy family, including pyrethrum and tagetes. As a protective charm, artemisia was hung over doors, worn in girdles and fashioned into little dolls. It appeared in Chinese herbals over 2,000 years ago, mainly as a fever cure, and was dedicated to the only female among the Eight Immortals, He Xiangu, protector of domestic life. Similarly, the ancient Greeks dedicated the plant to Artemis, goddess of healing.

Bamboo

The Ten Bamboo Studio in Nanjing was the home of the scholar
Hu Zhengyan, a painter and calligrapher. There his artist friends
assembled, and around 1643 published a collection of coloured
woodblock prints from their albums (see overleaf). The link
with bamboo is apposite, because the painting of bamboo leaves
was one of the supreme expressions of the artist/calligrapher's
skill, acquired from observing nature and copying the work of
exemplars – which these albums were intended to be. Bamboo
was integral to much of Chinese life, from fireworks and weapons
to musical instruments and utensils. Before paper was invented,
Chinese books were written on bamboo strips, strung together
with thread, and since these 'bamboo annals' were buried with
the great, examples have survived from the fifth century BC. The
Chinese had maxims on concentration, such as 'paint bamboo
with the finished image in mind', along with traditions comparing
fortitude to the toughness of bamboo. Zheng Banqiao (1693–1765),
one of the great bamboo painters, was a magistrate working against
corruption and injustice who was banished to the countryside for
his efforts. Alongside one painting his calligraphy reads 'in my
office I hear the rustle of bamboo and wonder if it is the sobbing
of the people'.

入門穿竹徑留客聽

山泉　十竹齋寫

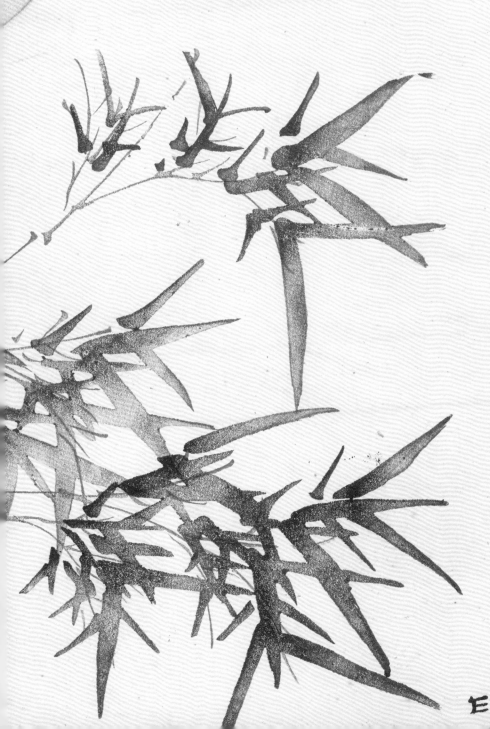

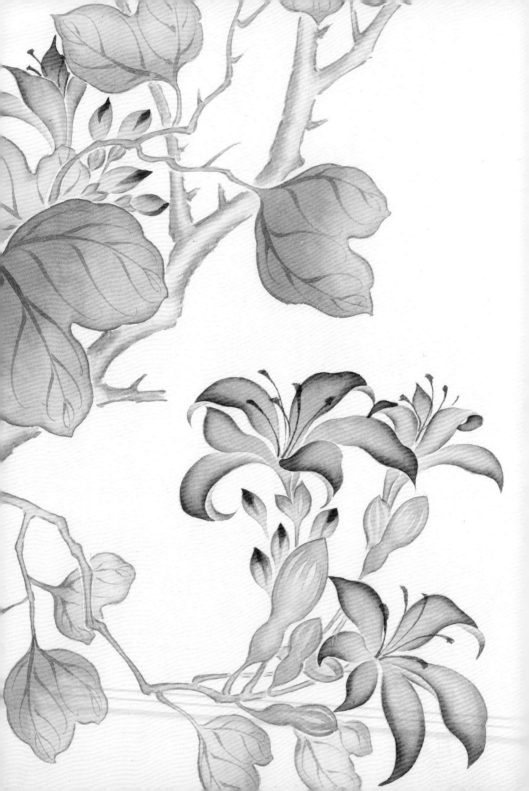

Bauhinia

There are many species of bauhinia in tropical Asia. Some are twining creepers such as *Bauhinia scandens* (the snake climber), but most are small trees widely planted for their beauty and long flowering season. Bauhinia flowers are usually purple/pink, often patterned with streaks of denser colour and graced with prominent stigma and stamens. Common names for bauhinia include butterfly tree and camel's foot – both inspired by the shape of the leaves. The flaunting flowers earned it another name, orchid tree, and both plants share eclectic methods of survival: some pollinated by insects, others by birds, including sunbirds, or bats. For seed dispersal the pods of *B. purpurea* shoot long distances; those of *B. pinata*, which is a coastal species, float. *B. variegata* is valued because the flowers and leaves are considered edible (in curries) and medicinal. Bauhinias also provide dyes and timber. In 1997 *B. blakeana* became the emblem of Hong Kong, a unique species propagated from one tree found on the island in 1880, deemed to be a cross between *B. purpurea* and *B. variegata*. It was named after Sir Henry Blake, the British Governor of the island from 1898 to 1903, during the period when the New Territories were annexed.

Bombax

On his botanical travels William Roxburgh found bombax trees up to 30 metres (nearly 100 feet) tall growing in the uplands of India. At the end of the cool season, before the leaves returned, he admired how the trees were decked in 'many huge, bright red flowers'. Bombax is the cotton tree of Asia, a relative of the cotton shrub itself, though far larger, and indigenous eastwards from India to southern China. The silky mass of fluff that surrounds its seeds is used for stuffing everything from bedding to quilted garments, but this kapok is no substitute for cotton because the shortness of the fibres makes it useless for spinning. It is also slightly inferior to the kapok of tropical America, *Ceiba pentandra* – which has replaced bombax to such an extent in Indonesia that ceiba is known as Java cotton. The bombax tree provides a soft, light wood and its leaves, young roots and flowers are all edible. In India their beauty was associated with the god Vishnu, while the Chinese expressed their admiration by adding bombax to their albums of paintings, classifying bombax among the fragrant and beautiful flowers.

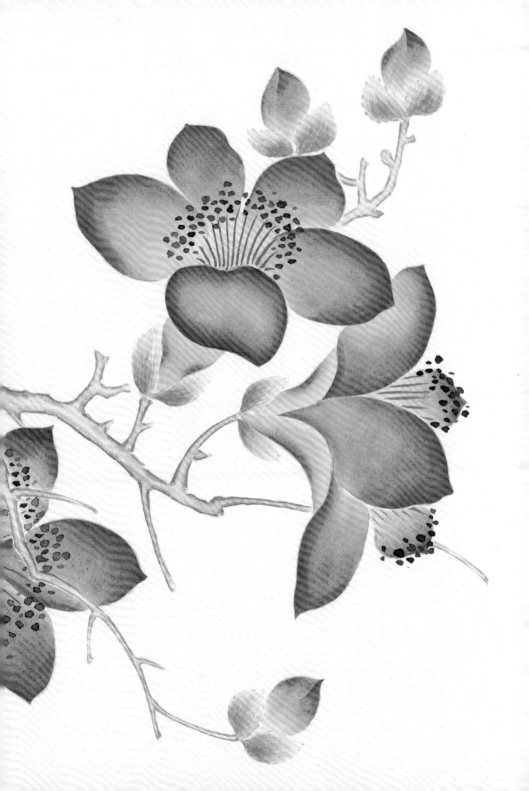

Camellia

Camellias were first cultivated in Yunnan in China, the heartland of the wild species, long before records of the Song dynasty (960–1279) detailed the development of various double and variegated flowers. Their Chinese name *C'ha hua*, tea flower, acknowledged the close relationship between the two species, and the first camellias to arrive in Europe were 'possible tea flowers that nobody wants'. The largest flowers belong to *Camellia reticulata*, but the most widely cultivated is this one, *C. japonica* – a misnomer that arose because the first botanical description in Europe, in 1712, was based on flowers Engelbert Kaempfer saw in Japan. But the species native to Japan is *C. sasanqua*, and Kaempfer also used the Japanese name *tsubaki*. An oft-repeated refrain *'tsura-tsura-tsubaki'* appeared in the oldest existing Japanese poetry anthology, *The Collection of 10,000 Leaves*. It recalled an eighth-century visit to the 'spring fields of Kose', a breathtaking area of wild flowers at the base of the volcano Mount Asama, including massed camellias. In the great Japanese scroll of *One Hundred Camellias*, painted in 1635, such quotations featured alongside the flowers. Even the sweet buns called *tsubaki-mochi*, sandwiched between two camellia leaves, had a literary history dating back to the *Tale of Genji*.

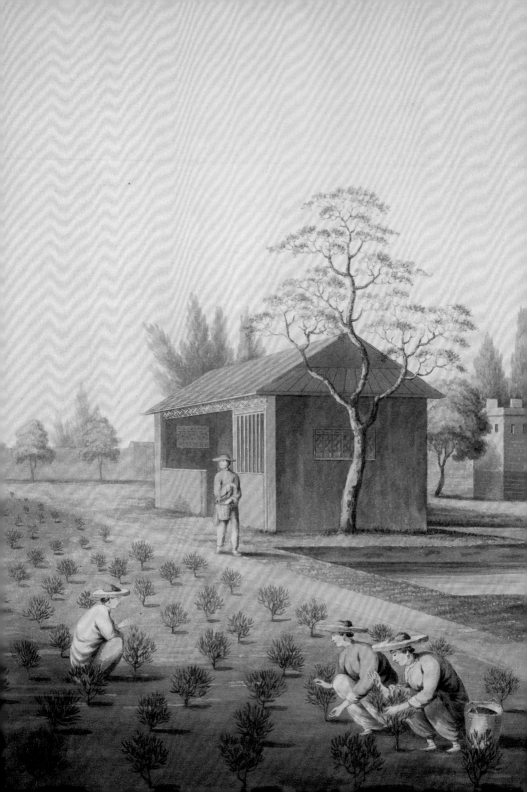

CAMELLIA SINENSIS

Tea

While tea became the drink of
fashionable Western society, enhanced
by chinoiserie teapots and cups, China
resisted commercial expansion, except
at gunpoint, and accepted only bullion
in exchange for tea. Into this troubled
situation stepped Robert Fortune,
intrepid plantsman, in search of
Chinese tea plants which could be transported to India to improve
the plantations there – which had first been supplied with plants
smuggled out of Canton (Guangzhou), far to the south of the tea-
growing areas of China. Fortune arrived in 1842, at the close of the
first Opium War, in which Britain had captured Hong Kong and
opened up five Chinese treaty ports, including Shanghai.
Although he was forbidden to travel inland, his accounts of the
cultivation and manufacture of tea earned him the patronage of
the East India Company for his subsequent expeditions. In 1848,
disguised in Chinese costume, Fortune travelled by boat along
the internal waterways, and on foot over high ground, visiting
both the green tea and black tea areas, and discovering that the
difference lies mainly in the processing. With Chinese agents
collecting for him, Fortune finally left for Calcutta in 1851,
with quantities of tea plants and a team of tea producers.
But eventually Assam tea bushes proved more suited to the
Indian climate, and more to European taste.

Japonica

Japonica does indeed come from Japan, where it is highly favoured as a bonsai plant. It bears red blossom, with white or pink varieties, and golden fruit closely related to quince, but smaller. It was first described by Carl Peter Thunberg in *Flora Japonica* (1784) under the name *Pyrus japonica* (now *Chaenomeles japonica*) after he found it growing near Mount Hakone, where he was allowed (briefly) to botanise while accompanying the annual Dutch embassy to Edo (Tokyo). Ten years later, Joseph Banks at Kew received the Chinese species, now called *Chaenomeles speciosa* or *C. lagenaria*, which looks very similar except that the flowers open before the leaves on almost bare branches, and the fruits remain very small and green. This first plant possibly arrived with the return of Lord Macartney's embassy to China in 1793 (which failed to improve trading relations, ostensibly because the English refused to kowtow to the Qianlong emperor). Much early confusion arose between these two species, but they both retained the name japonica, and the main garden hybrid is *C. superba*, a cross between them. The Chinese themselves favour *C. sinensis*, which has flowers more like apple blossom and much larger fruit. This is especially relished in candied forms (similar to membrillo, or quince paste, the European equivalent).

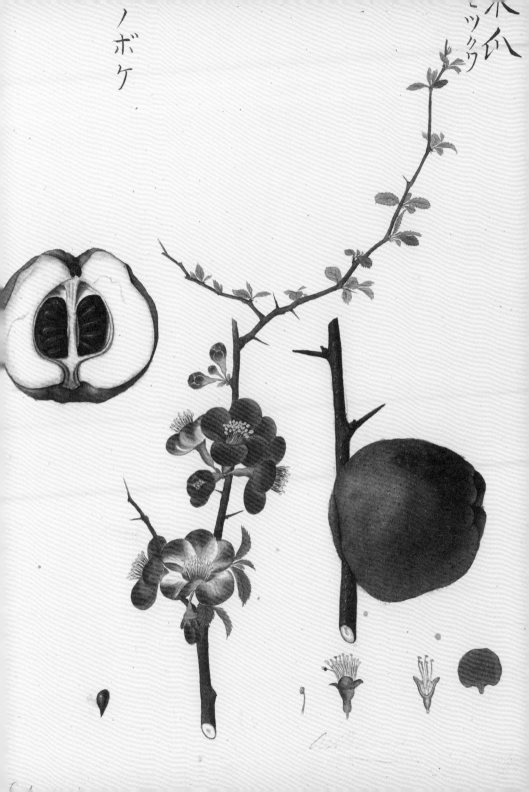

木瓜
ニツクワ

ノボケ

商枝未同燈
我作呃揚

CHIMONANTHUS

Wintersweet

Chimonanthus grows wild in China, where it is treasured for its pervasive fragrance during the wintry season of Chinese New Year. The little waxy flowers are yellow or ivory with maroon inner markings, and they used to be strung on fine wire to make hair ornaments for women, while twigs were laid in their clothes chests. Chimonanthus was brought into garden cultivation, probably during the Song dynasty (960–1279). It was then that the leading eleventh-century poet and calligrapher Huang Tingjian wrote a poem that has been associated with it ever since, which describes how the fragrance of flowers is a distraction from meditation. Chimonanthus travelled west overland as far as Iran, where it was named ice flower, and eastwards it arrived in Japan possibly not long before Kaempfer described it in 1712, growing near the Dutch concession at Dejima. It reached England in 1766 and first bloomed at Croome Court in the Earl of Coventry's conservatory. Chimonanthus was recognised as a close relative of calycanthus, the recently introduced Carolina allspice, and was correspondingly named Japanese allspice; but its more poetic name is wintersweet.

Chrysanthemum

The original yellow chrysanthemums of China, *Chrysanthemum indicum*, were scrawny wild daisies. The poet Li Qingzhao, lamenting her absent husband, complained, 'I am thinner than a yellow flower'. But they became a favourite seasonal and decorative flower. During the autumn moon festival, the emperor and all his retinue, and everyone all over China, climbed to the top of the nearest auspicious hill and drank chrysanthemum wine to ensure health and long life. Hybrids combining yellow, red and white species, classified as *C. grandiflorum* (see overleaf), created a rich array of colours, which artists sought to capture with a watery technique known as gradient colour, while poets such as Tao Qian (c. 365–427) sang their praises: 'The autumn chrysanthemums have the loveliest colours / Flowers and leaves all moistened with the dew'. In Japan, chrysanthemums were bred for extravagant petal formations, with names like golden bells, jade basin, pink silk threads, purple crab's claws and drunken lady – the last had petals erect at noon and droopy in the evening, a sign of heliotropism shared with other daisies and sunflowers. Indeed, in Japan chrysanthemums were symbols of the sun, and of imperial might, and they arrived in eighteenth-century Europe as living examples of the luxuriant blooms depicted on fashionable artefacts imported from the East.

瑞色十斤
爪金丁子
一尺一寸
二分

明石

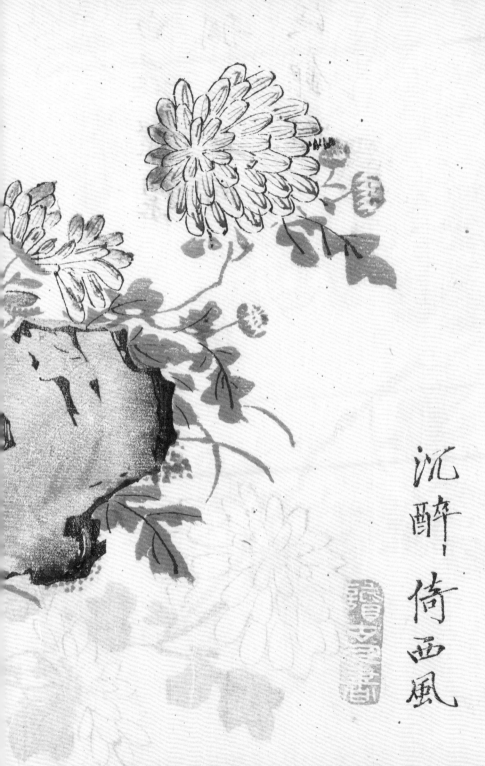

沉醉倚西風

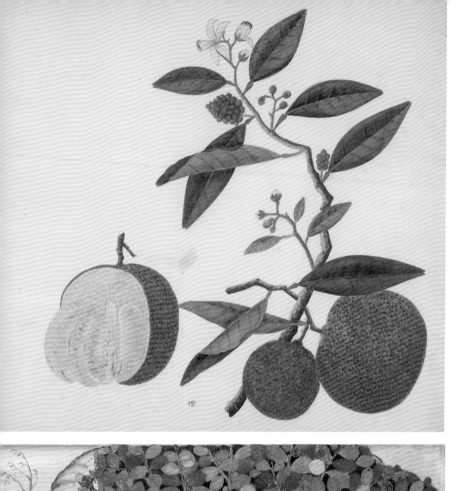

CITRUS

Orange

All citrus fruits are native to southern Asia, from tiny oranges
on spiny shrubs to the largest *Citrus maxima*, the pomelo or
shaddock, which is an ancestor of oranges and grapefruit.
The other ancestral species are *C. medica*, the citron of Indochina,
from which lemons and limes derive, and *C. reticulata*, whose
cultivars are mandarins, tangerines, satsumas and clementines.
The first oranges to travel westwards were *C. aurantium* (Seville
oranges), which were valued for perfumed oils and flavouring.
Their cultivation owed much to Arabic planters, who brought
them to Sicily, North Africa and Spain, and Arabic poets were
the first to compare the fruits to golden lamps in a green night.
The Mughal emperor Babur described the area where oranges
grew in the Bagh-e-wafa as the best part of his favourite garden:
'In the southwest part there is a reservoir round which are
orange trees and a few pomegranates encircled by a trefoil
meadow. The most beautiful sight when the oranges take colour.'
Sweet oranges, *C. sinensis*, arrived in Portugal from China in the
seventeenth century, and trees were brought to England when
Catherine of Braganza married Charles II. Samuel Pepys saw his
first orange growing in Hackney in June 1666.

Citron

Citrus medica, the citron, is one of the four ancestral citrus fruits from which all others developed, and is most closely related to lemons and limes, though the large yellow fruit consists mainly of pith and peel. One variety, *C. medica var. sarcodactylis*, the fingered citron, has evolved an eccentric shape that Chinese artists found delightful; it is also valued for flavouring because the pith is unusually sweet and the whole fruit can be used candied, or in puddings or savoury dishes. It can also perfume a room, or a clothing chest. The name Buddha's fingers hints at the fruit's festive associations as a temple and New Year offering. Sometimes the segments forming the fingers (far more than five) are spread wide, but at other times they are closed like a fist, or an incurved praying hand. Some say the citron originated in India and was introduced by Buddhist monks; others that it is a Chinese variety from the Yangtze valley. It now grows mainly in China, Japan, Korea and Malaysia, loved as an ornamental as well as a useful fruit. The albums of the Ten Bamboo Studio (in seventeenth-century Nanjing) were printed as painting manuals, and here the uneven skin of the citron demonstrates certain methods of colour shading, which was one of the most skilled techniques needed for both painting and printing.

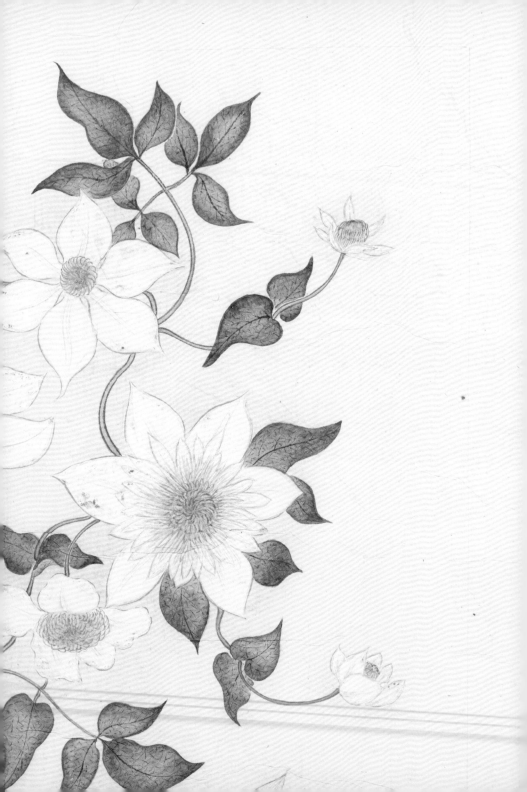

Clematis

There are wild clematis in Europe and America (*Clematis viticella, C. cirrhosa and C. alpina*) but the larger blooms are Chinese, though they arrived via the gardens of Japan. *C. florida* (opposite), with large creamy flowers and an extra row of petaloids giving a double appearance, was named in 1776, with further cultivars dispatched by Philipp Franz von Siebold in 1836. In 1850 Robert Fortune, on his final expedition to the tea plantations of China, sent back to Britain *C. lanuginosa*, the largest-flowered of all Chinese species. This set the stage for hybridising with European stock to maximise hardiness, in which George Jackman & Son led the field – *C. jackmanii* remaining unsurpassed for healthy appeal. Jackman suggested his customers plant a clematis garden called The Climbery, or transform with clematis 'those grotesque arrangements of old tree stumps to which the term Rootery is applied'. Other Asiatic clematis included: *C. orientalis* from the Levant; the over-vigorous *C. montana* of the Himalayas (introduced by Lady Amherst); the yellow Chinese lanterns of *C. tangutica*; and the fragrant evergreen *C. armandii* introduced by Ernest Henry Wilson in 1900.

CODONOPSIS

Bellflower

This lovely campanula or bellflower is a climbing plant, so its subtle greenish flowers with purple veins can be admired at eye level, the delicacy of the flowers belying the vigour of its twining stems. Various species of codonopsis grow across Asia, from Iran eastwards, but it is mostly cultivated in the Far East where, under the influence of traditional Chinese medicine, it is known as poor man's or bastard ginseng. As with ginseng, it is the long tap root that is harvested, but since codonopsis matures much faster than ginseng it is neither expensive nor rare. Its medicinal properties have not been confirmed by research but, like ginseng, it appears to stimulate the central nervous system, acting as a tonic. In China and Japan the main species is *C. pilosula*; in Korea *C. lanceolata*, where it also forms part of their cuisine and is known as dudok root. Codonopsis was first described in the 1820s from Indian plants known to William Roxburgh, and soon after in Japan it was illustrated in Philipp Franz von Siebold's *Flora Japonica*. The Japanese artists working for Siebold established a style of botanical illustration which combined their own linear grace with greater scientific awareness, exemplified here in the work of Tachibana Yasukuni, illustrator of *Wild Flowers of Japan* (1873).

estis si ea que prīpio facitis Ac si aperte dicat
Gaudetis de culmine. pensate quibj laboribus
puenit ad culmē. Tu. R̄ tues aplorū et do
mestia dei aduenerūt hodie portantes pacem et illuitantes
pātriā. Pace pace gentibj et liberare ipl'm dm̄ Xp̄n omnes
tram exuit sonus eorr et in fines orr t' ur eorr. Dure X
Am non dicam uos seruos. quia seruus nescit
quid faciat dn̄s eius. Vos aut dixi amicos. qa
omīa quetucq̃ audiui a pr̄e meo nota feci uo
bis. Que sunt omīa que audiuit a pr̄e suo. q̃
nota fieri uoluit seruis suis ut eos efficeret ami
cos suos. nisi gaudiā etīe claritatis. nisi illa
festa supne patrie. que nr̄is cottidie mentibj
paspiratcēm sui amoris iprimit Dū em̄ au
dita supna celestia amamq̃ amata ia noui
mq̃ quia amor ipe notitia est Omīa ergo
dn̄s discipulis suis nota fecerat qa a terrenis
desideryis imutati amoris sui caribj arde
bunt Istos uero amicos dei aspexerat ipp̄ha
cū dicebat Michi aut nimis honorificati ī
amici tui deus. Tu. R̄ fuerūt sine querela ante
dn̄m et abinuice nō sūt separati. Calice dn̄i biberūt et
amici dei facti sūt Xp̄ Tradiderūt corpa sua ip̄ter deū
ad suppliria ideo coronant et acripiūt palma. Ca Gl̄a Ca
Te deū laud' Ālaudes Xp̄ constitues e laud' an

oc est pr̄eptū meū ut diligatis inuice sic dilexi
uos pr̄ Dn̄s regi tu cetis An Maiorē caritatem
nemo habet ut aīam sua ponat quis p amicis suis Ca

CROCUS SATIVUS

Saffron

The saffron crocus still grows wild in Iran, where its pigments have been used from prehistoric times. From there cultivation spread, giving rise to different strains. The rarest, in Kashmir, has maroon stigmas, but usually they are an intense orange-gold. It is from these – the prominent female parts of the flower – that perfumes, flavourings and dyes have been extracted. But harvesting is delicate and labour-intensive; several thousand crocuses yield only a small scoop of saffron. Hence the value of saffron and the confusion with adulterants, especially the equally yellow turmeric and an orange thistle named safflower. A botanical work from the Library of Assurbanipal in ancient Assyria mentioned saffron, and when Alexander the Great conquered Persia he took saffron-scented baths. In China saffron was first mentioned in the seventh century, arriving 'from India, with purple autumn flowers, their fragrance strong from a distance, but with no seeds – if you wish to plant it you must take the root'. The poets of the Tang dynasty (618–906) were enchanted; for them, 'gold aroma', as saffron was called, evoked dancing girls wafting the perfume from their sleeves, or better still bed hangings.

Turmeric

Turmeric, the colouring spice of curries, which appears in golden heaps in Asian spice markets, is also known as Indian saffron, and its Latin name *Curcuma* derives from the Arabic name for both. As Marco Polo made his way eastwards he marvelled to find another, cheaper, product so like saffron (in colour at least). This bright yellow distinguishes turmeric root from other members of the ginger family, and made it extra special in Indian culture where yellow-orange has always been a sacred colour. For Hindus and Buddhists it is the colour of monks' robes (turmeric yields a yellow dye). During the spring festivities of Holi, where being bombarded with dye colours is part of the fun, turmeric was, as Roxburgh commented, 'copiously thrown about'. At Indian weddings the bridal couple may still be smeared golden with turmeric. Cultivated turmeric *Curcuma longa* (shown here), is a hybrid which does not set seed, though it reproduces vigorously from rhizomes. It is thought to have arisen by selection and vegetative propagation from wild ancestors, one of which was the widespread *C. aromatica*, which grows from India through to Vietnam and southern China.

Curcuma Zerumbet.

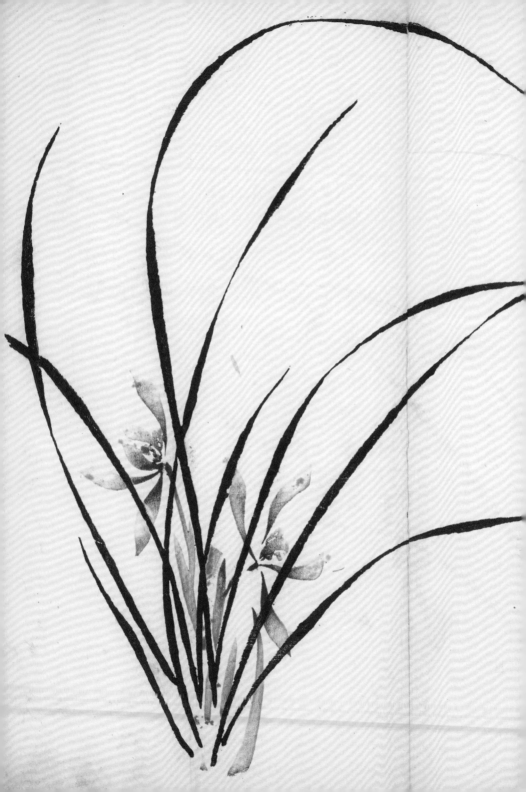

Cymbidium orchid

For the poets of China's Tang dynasty (618–906), orchids meant fragrance and fragility: appropriate for both romance and scholarly pursuits. Li Shangyin described assignations in 'the chamber with an orchid-fragrant curtain'; Wang Wei wrote: 'Lovely the landscape in the setting sun / You and I writing poems together / Spring wind shifting all the grasses / Scented orchids growing in my hedge'. The orchid beloved of Chinese artists, poets and collectors is the cymbidium, with its graceful, grass-like foliage, haunting fragrance and greenish flowers marked with ever-varying patterns of brown/purple/yellow. It is quite unlike the fleshy wonders of tropical Asia. The spring orchid, *Cymbidium virescens* (shown here), bears a single flower but is the most fragrant. Two summer-flowering species, *C. ensifolium* and *C. pumilum*, have many-flowered spikes, which last over two months. Connoisseurs nurture them in specially designed pots, pay vast sums for intricate variations in flower-type, and allow no other mortal to handle them. For artists, painting an orchid exercises the same skills as fine calligraphy: a few deceptively simple brushstrokes requiring much skill and practice. The subtle colours are less important than the rhythmic lines expressing the vitality of the plant.

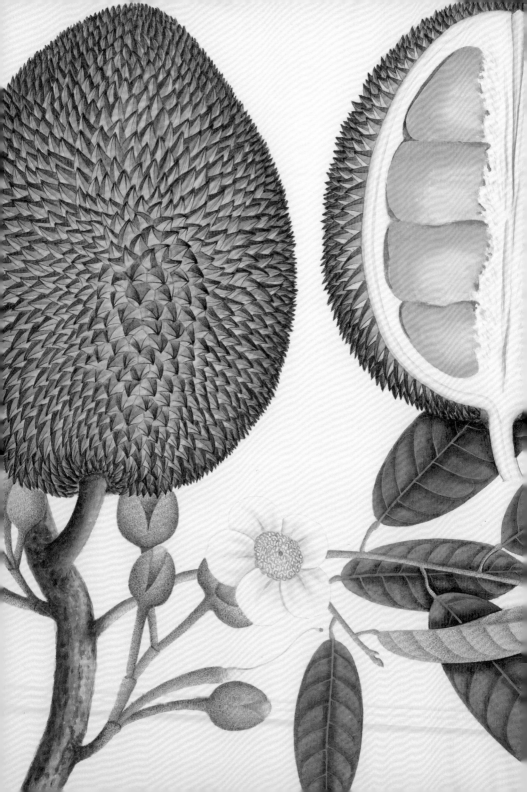

Durian

Durian (*Durio zibenthinus*) is a fruit the size of a football from a large tree native to the forests of Borneo, Malaysia and Indonesia, which is now extensively cultivated in South East Asia. Inside the spiky green shell the seeds of durian are surrounded by a pulpy aril (fleshy envelope) which, according to one Victorian explorer, tastes like 'caramel and cream with a hint of strawberries'. The smell, however, is atrocious, described by the same explorer as 'onions, drains and coal gas'. But nature has its reasons; in the forests the smell of the ripening fruit would attract elephants, tigers, monkeys and many other creatures to join the feast. Durian was first described to Europeans by G. E. Rumpf in his *Herbarium Amboinense* (1741) and later its magnificent appearance (mercifully removed from its smell) made it a popular image of exotic fruit. Collections of natural history drawings expressed the growing fascination with botanical discovery, exemplified by Lord Wellesley, Sir Stamford Raffles and Thomas Hardwicke, who all employed local artists. Raffles first recorded employing a Chinese artist from Macao in 1810, and subsequently the atelier he established at Bencoolen in Sumatra produced over 2,000 drawings – although most were lost at sea.

ERYTHRINA

Erythrina

Erythrina, or coral trees, are pan-tropical, and while some of them do bear flowers the colour of coral, they range richly across the pink/orange/red/purple spectrum. The flowers are always in dense clusters. Some erythrinas show their family resemblance to large pea-flowers, but in other species the flowers are shaped more like horns. They are pollinated by birds, from sunbirds to starlings, which flock around and sometimes emerge dripping with nectar. As members of the legume family, erythrinas bear their seeds in pods, which are long and dark, and the seeds are very like beans. The dominant erythrina of Asia is the Indian coral tree, *E. variegata*, also known as tiger's claw for the black spines along its branches. This makes it extra useful as a support tree for trailing crops such as pepper, vanilla and gourds. Because it is so beautiful, it is grown across South East Asia as far as Japan, and in both Hindu and Buddhist folklore it is considered a tree to grow in a sacred garden. Since the plant contains alkaloids it also has narcotic properties.

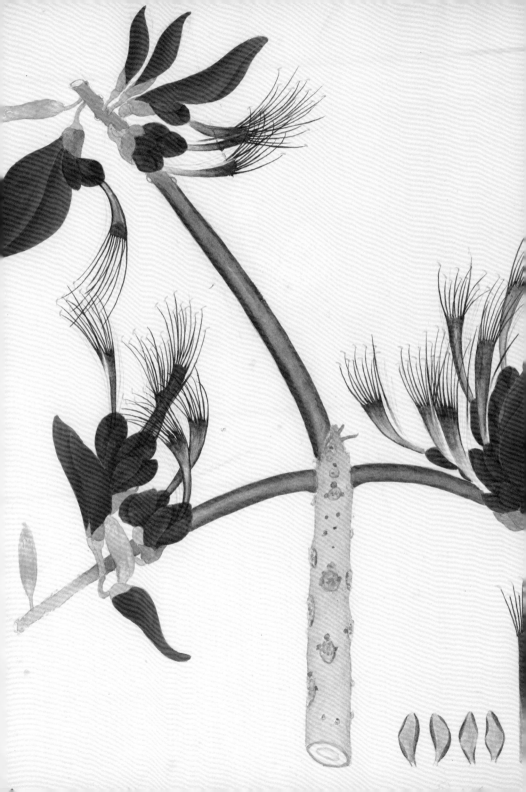

レンキョー

Forsythia

In China and Japan forsythia is valued not just for the masses of golden bells that it produces in spring, but also for its medicinal oils (it is a member of the olive family) which are used to treat skin afflictions. *Forsythia suspensa* (shown here), was first described in Carl Peter Thunberg's *Flora Japonica* in 1784 and introduced to Europe by the Dutch in 1833 from the island of Dejima. Shortly after, Robert Fortune sent *F. viridissima* back to the Horticultural Society (formed in 1804 and gaining the prefix Royal in 1861). Forsythia was part of the consignment that Fortune discovered in Chusan, an island off the treaty port of Shanghai, where he first realised the glories of China's flora. In 1848 Fortune journeyed to the interior of China in search of tea plants and discovered forsythias growing wild and lovely, including *F. suspensa fortunei*. The genus (which Thunberg had originally named *Syringa*) was called *Forsythia* after William Forsyth, one of the Horticultural Society's founder members, each of whom bestowed his name on a genus. Forsyth was gardener at St James's Palace, London, but marred his reputation by marketing a useless concoction that he claimed would heal damaged tree branches – Forsyth's Plaister became notorious.

Fritillary

Fritillaries are predominantly, though not exclusively,
Asiatic plants with hanging bell-flowers and a foxy smell.
Characteristically, the Chinese have discovered medicinal qualities
(cough remedies) in their indigenous *Fritillaria cirrhosa* and
F. verticillata. The largest fritillary, which grows in swathes of
springtime orange across the barren landscapes of Central Asia,
is the crown imperial, *F. imperialis*, which was adopted into
Persian, Turkish and Mughal gardens. There are six nectaries
inside the flowers, like teardrops, which inspired a Persian legend
about an abandoned princess. Shortly after *F. imperialis* reached
Europe, John Gerard compared these nectaries to 'fair orient
pearls', and John Evelyn received a letter suggesting that the 'lilies
dropping forth myrrh' in the *Song of Solomon* might be crown
imperials. During the 1630s the Dara Shikoh Album was created
for a Mughal prince, son of Shah Jehan and Mumtaz Mahal
(for whom the Taj Mahal was built). Working primarily in
the style of Persian miniatures, but also inspired by European
examples of painting individual flowers, the artist indulged an
urge to curve stems into arabesques, add extra flowers and petals,
and alter the colours that nature intended.

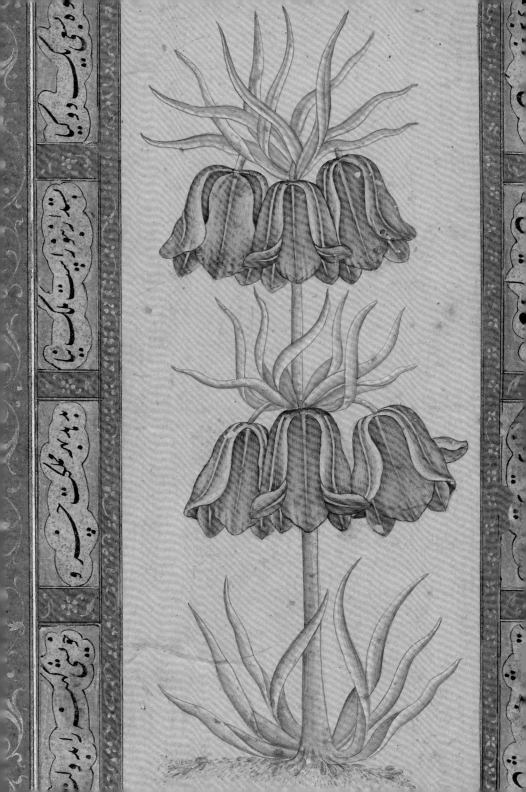

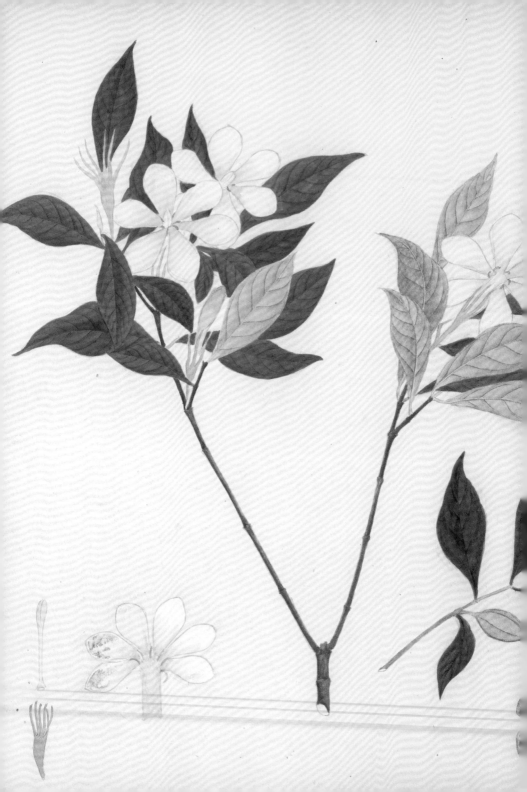

Gardenia

Different species of gardenia grow throughout tropical Asia. The first Europeans to record them were Dutch botanists in the East Indies, and the plants earned the misleading name Cape jasmine since they reached Europe via the Cape of Good Hope. Gardenias grow to the size of small trees in the tropics, but they have never been an easy hothouse plant, although they reached the height of fashion in elegant society during the nineteenth century. Paul Gauguin restored the flowers to their rightful environment when he painted them in the hair of his Polynesian beauties: worn behind the right ear, a gardenia signified availability; behind the left ear, the opposite. The largest gardenia flowers are *Gardenia grandiflora* (also called *G. jasminoides* because of their scent), a favourite of Chinese artists ever since the Song dynasty (960–1279), as they exercised their skills by delicately defining the white petals against a white background. Early Chinese texts recorded gardenia in use as a yellow dye, extracted from the fruit, effective both for textiles and food; and in Chinese medicine gardenia was considered both soothing and invigorating, qualities still attributed to the scent in modern aromatherapy.

Gloriosa

This climbing lily is a weed of tropical Asia, except in India where it is so valued in herbal medicine that its survival is threatened. Its strange beauty is compelling: the climbing tendrils curving from its leaf-tips; the reflexed petals shading from greenish yellow to red; and the sexual parts very prominent. The whole plant is toxic, containing poisonous alkaloids, especially colchicine, but the tubers and seeds are harvested and processed as potions to treat many ills, from arthritis to parasites. Also, because of its effect on cell division, gloriosa may be anti-carcinogenic. But, more crudely used, gloriosa's association with murder, suicide and abortion has been widespread. Gloriosa was first brought to Europe in the seventeenth century from the Dutch trading colony of Ceylon (Sri Lanka). In the eighteenth century it was delicately painted *in situ* by Indian artists working for natural history enthusiasts such as Thomas Hardwicke. As a soldier in the East India Company army, Hardwicke arrived in India in 1777 and when he finally returned to London in 1823 his collection totalled 4,500 drawings, and was put on public display in Lambeth. His botanical expertise was recognised and he became an influential member of the Royal Society and other scientific bodies.

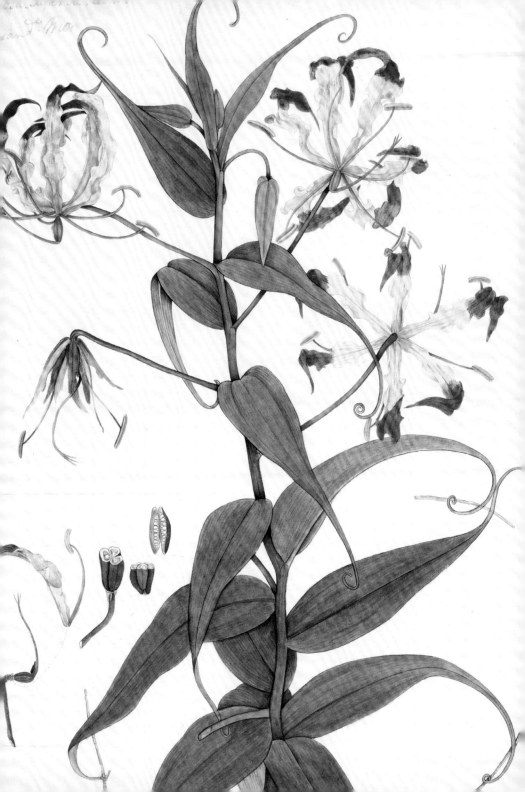

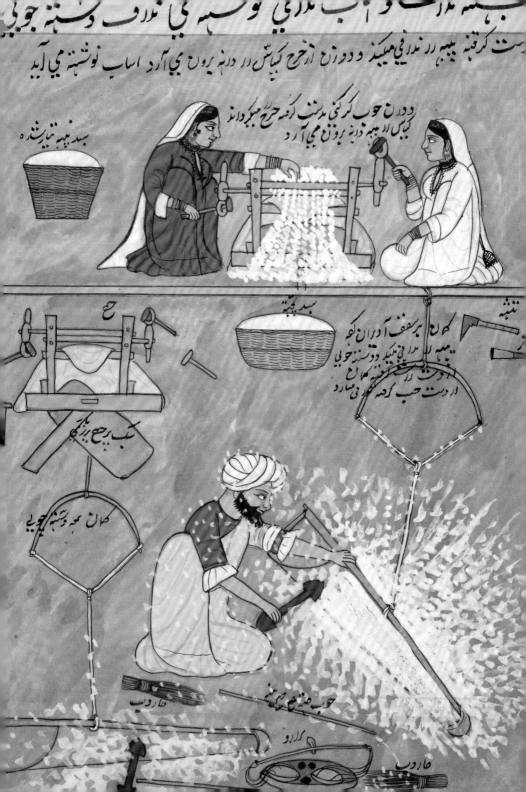

GOSSYPIUM

Cotton

草ノ
綿ノ
ワ
タ

Cotton seeds are surrounded by a white fluff of fibres called a boll, from which the most important natural fibre known to man is spun.

The Indian species, *Gossypium arboreum*, was cultivated first in the Indus valley around 5,000 years ago and from there spread across Asia, while indigenous species of gossypium were similarly developed in tropical Africa and America. Arab traders brought cotton to Europe, until in the seventeenth century the East India Companies took control. The names of the fabrics they introduced acknowledged their origins: calico from Calicut; muslin from Mosul; and chintz from a Hindi word meaning brightly scattered colour. The traditional Indian method of ginning cotton by hand is demonstrated here in the Kashmir Album. First the bolls have to be rid of plant trash and insects, and the mass of fibres pulled free of the seeds, all pointing in one direction. The man with a beater and bow performs this function, known as twanging, after which the cotton is rolled into 'cigars' ready for spinning into thread, then weaving and dyeing. The invention of machines in Europe, and changes of fashion, reduced nineteenth-century India merely to a source of raw cotton, threatened even in this by American production, until Gandhi initiated a resurgence which once more placed Indian textiles at the forefront of world trade.

Day lily

Day lilies (like rhubarb) were among the earliest plants to be brought along the ancient Silk Route from the Far East to Europe, since they were believed to deaden pain, including that of childbirth and grief – a property scientifically supported by chemical research. The Book of Odes, the oldest surviving poetry collection in China, contained the ballad of a woman longing for a distant husband: 'How shall I get the herb of Hsuan / And plant it north of the house / My heart is hurt and aching'. In China and Japan day lilies were also believed to favour the conception of male babies when worn in a woman's girdle. Early in the Middle Ages the yellow *Hemerocallis flava* was naturalised in eastern Europe, 'gilding the meadows of Bohemia', and later the tawny-orange *H. fulva* arrived via the Near East. A fifteenth-century herbal classified 'anfodilli' as a narcotic alongside daffodils and asphodels. In China and Japan, dried flowers and roots still appear on the shelves of herb stores. The flowers have always been admired, often painted, and eaten as a delicacy known as golden vegetable or gold needles, which is sweetish and mucilaginous.

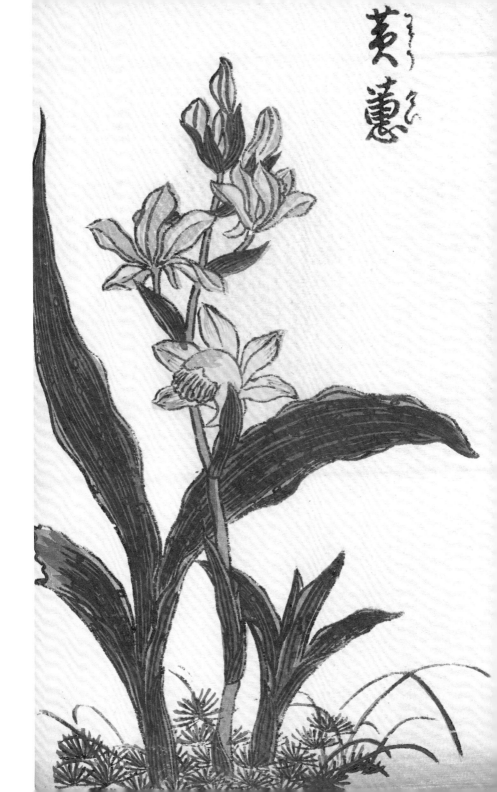
荔
蕙

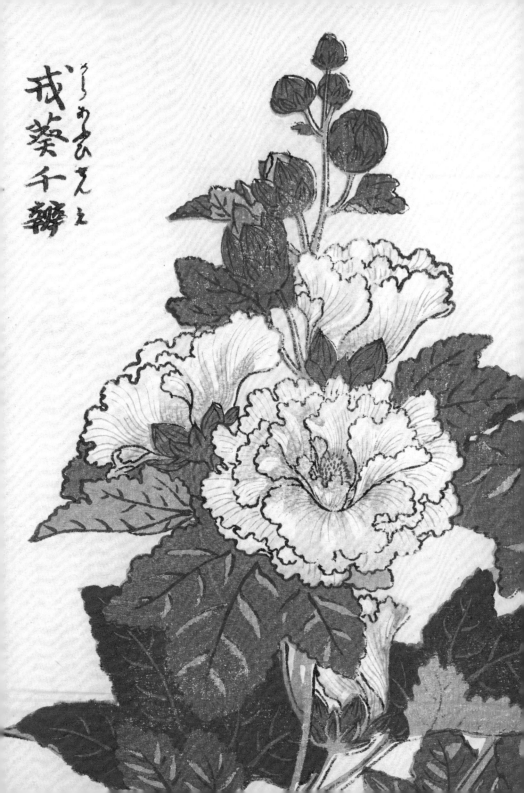

戎葵千辧

Hibiscus

All hibiscus originate in the Far East, although *Hibiscus syriacus* found its way to the eastern Mediterranean so early that it was assumed to be indigenous. This is the hibiscus best known to Europe. The Chinese favourite is *H. mutabilis*, so called because it is white in the morning when it opens, and turns a deepening pink through the day. It grew prolifically on the city walls of Chengdu, capital of Sichuan province, transforming its colour so dramatically from a distance that it was called 'city of pink silk'. Handsomer still is *H. rosa-sinensis* (shown here), a flower widespread in tropical Asia, but thought by the Chinese to originate in fairyland. In Chinese folklore, this land of immortals consisted of three islands in the eastern ocean which no boat could approach through the stormy seas. The first emperor of China, Qin Shihuangdi (ruled 221–210 BC), dispatched an expedition to seek the islands of the immortals but it never returned. Gradually they were assumed to be Japan, but the legend remained a fitting tribute to these lovely flowers, though they certainly did not last forever. The Tang dynasty poet Hanshan, who scratched his *Cold Mountain Poems* on rocks, wrote, 'I lament that hibiscus cannot bear the cold'.

Plantain lily

Hostas are native to China, Korea and Japan. When the plants
first arrived in Europe in the 1790s they were grouped with
day lilies, then simultaneously given two new generic names,
Funkia and *Hosta* – both in honour of contemporary botanists –
but the name hosta prevailed. The common name, plantain lily,
is more appealingly descriptive, although admirers would say this
fails to do justice to the leaves, which are considered the chief
glory of the plant (if they escape the depredations of slugs). In
some hostas the leaves are variegated with wide white or creamy
streaks, and *Hosta sieboldiana* (shown here) has a waxy leaf
coating that creates a subtle blue-green. These classy shades of
green inspired the Chinese name *Yu T'san*, jade hairpin, although
'hairpin' surely also alludes to the shape of the flowers and their
pearly lustre. *H. ventricosa* was first brought to Europe from Japan
in 1790, followed by *H. plantaginea* and *H. sieboldiana*, sent by
Philipp Franz von Siebold during his stay in the Dutch concession
of Dejima from 1826–30. Ostensibly Siebold was there as a
medical practitioner, but his enduring legacy was the collection
of plants that he made with the help of his medical students,
and the illustrations he commissioned from Japanese artists.

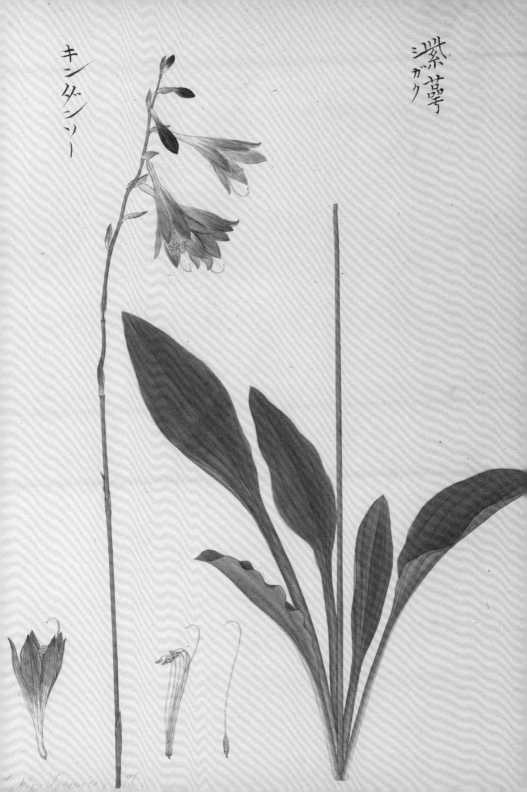

キン/ダ/ソ/

紫萼
シ
ガ
ク

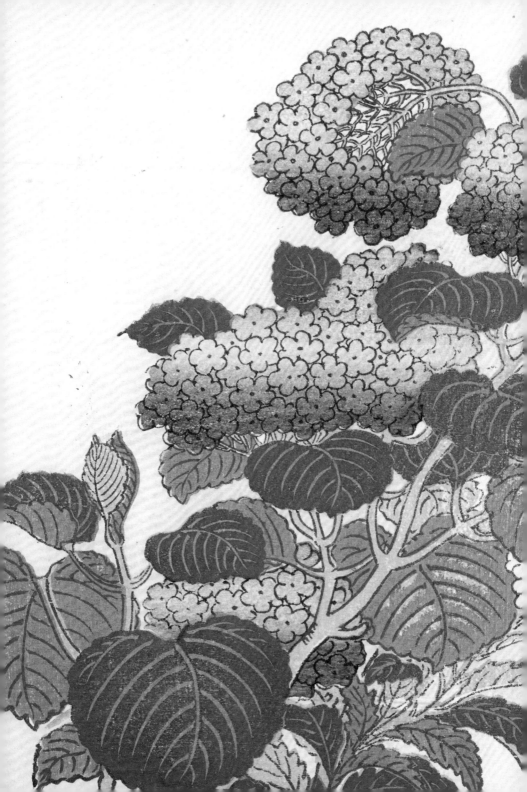

Hydrangea

Although hydrangeas are not exclusive to China and Japan, the finest garden flowers came to Europe from there, with *Hydrangea macrophylla* leading the way. The early arrivals were already garden cultivars developed over centuries, and they had only ornamental sterile flowers, rather than the smaller fertile ones. Engelbert Kaempfer, the first doctor/plantsman employed by the Dutch East India Company in Japan, described a hydrangea in 1712, thinking it was an elderflower, and in 1784 Carl Peter Thunberg brought back two dried specimens labelled 'viburnum'. In 1792 Kew recognised the link between the oriental plants and the less spectacular American hydrangeas that had arrived earlier. By the mid-nineteenth century, hydrangeas became a garden favourite, and as China and Japan were opened up, plant hunters were dispatched to search for new species – including the vigorous Japanese climber *H. petiolaris*, the tree-like *H. paniculata* (introduced by Philipp Franz von Siebold in 1862 after his second journey), and the lace-cap varieties of *H. macrophylla*. The delightful possibility that a pink hydrangea might turn blue was recorded in the 1790s, though the constituents of the soil necessary to make it happen took decades to unravel.

INDIGOFERA

Indigo

'The mountain named India, a heap
of blue dye', in the words of a Tang
poet. Local traditions of dyeing
with indigo can be traced in every
continent, but India became the
major centre of production in the
ancient world, giving its name to
the plant. As trade routes extended,
Indigofera tinctoria superseded
other indigo-producing plants, such
as European woad *Isatis tinctoria* or Japanese dyer's knotweed
Polygonum tinctoria. Extracting indigo is difficult and slow,
involving soaking, fermenting and oxidising, then drying into
cakes for trading. In the dye vat neither water nor alcohol dissolves
indigo. This needs stale urine or sulphuric acid to precipitate a
series of chemical changes, and when the submerged fabric is
removed it is yellow, until exposure to oxygen makes it revert to
blue. Success in indigo dyeing depends on skill, and so do the
patterning techniques. Tie dyeing reserves the base colour of the
fabric by pleating and tying with thread. For batik, wax or flour
paste is applied to block out areas that will remain undyed. The
process shown in this image from the Kashmir Album (opposite)
is discharge printing (later pioneered in England by William
Morris), where the pattern is bleached out of cloth already dyed
with indigo, before being immersed in a hot vat of red madder.

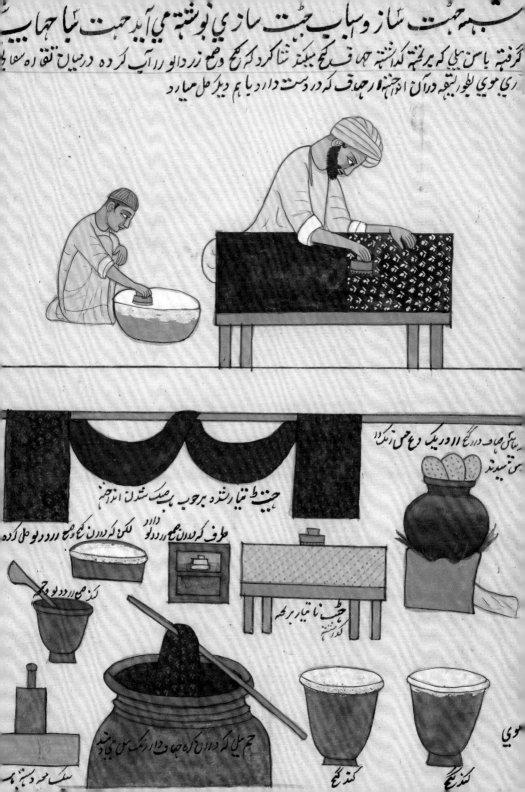

شبه جهت ساز و سباب جت سازی نوشته می آید جهت سبا جهاب
گرفته یاس هی که برنته کداشته حا فرکج بیکنه شنا کرد کرکج وه زردانو را آیه کرده دریاب نقاره سقا
ری موی للو ریتو دران انجه وار جهن و حق که در دست دار دیا هم دیگر حل میارد

سی هی جا و دررگ ۱۱ و دریک وه هی زنگ"
سی تیسند

حنت تیار رشده برجوب برجیک شدن انداجن

طرف کردون ماه رد رولو ملک که دردن زنگ شه که درریاب ردو ول کرده

کده ما رد رولو حجر

حنت تیار برجرجه
گدریس

حم میل که دران که جها دار رنگ سی گا سنه
سک جه دسه ناسر

کند گج کند گج موی

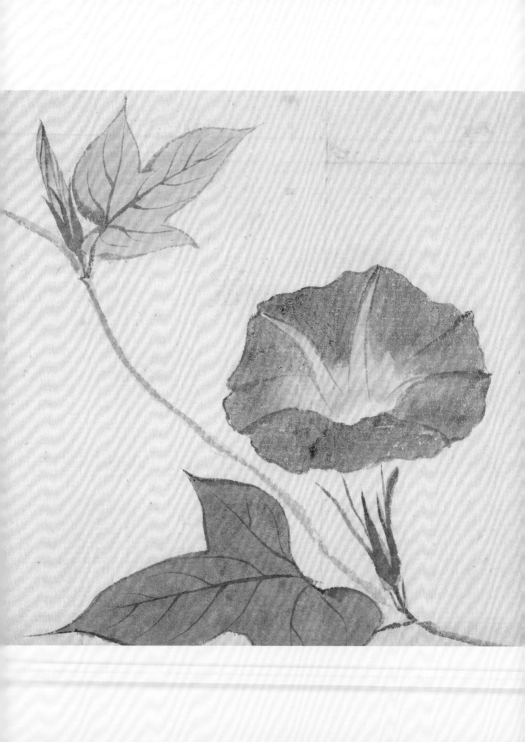

Morning glory

In Asia and Europe the native morning glories are *Calystegia*
species (bindweed) with pink or white flowers, which are lovely
when they open with the dawn, but wither to a miserable twist
later in the day. In China their rhizomes are eaten; in India their
young leaves; and in Japan they have literary connotations:
'A morning glory / And so today may be / my own life story'. But
the morning glory celebrated in Japanese haiku might have been
one of the *Ipomoea* species which, in the seventeenth century, were
transported worldwide from America, on account of their glorious
blue flowers. They even acquired the name Japanese morning
glory – which is certainly how Phillipp Franz von Siebold viewed
the blue flower when he had it painted for his personal album.
But in the twelfth-century *Tale of Genji*, morning glory would
have been a white flower (like evening glory). When Prince Genji
was wooing an old flame, whose name Asagao meant 'morning
glory', she proved reluctant. Staring over the mist-laden garden
and brooding over his rejection, he saw morning glory flowers
shimmering vaguely. Choosing the most wilted flower he sent it to
her with this note: 'can it be that the morning glory is now a dry
and withered flower?'

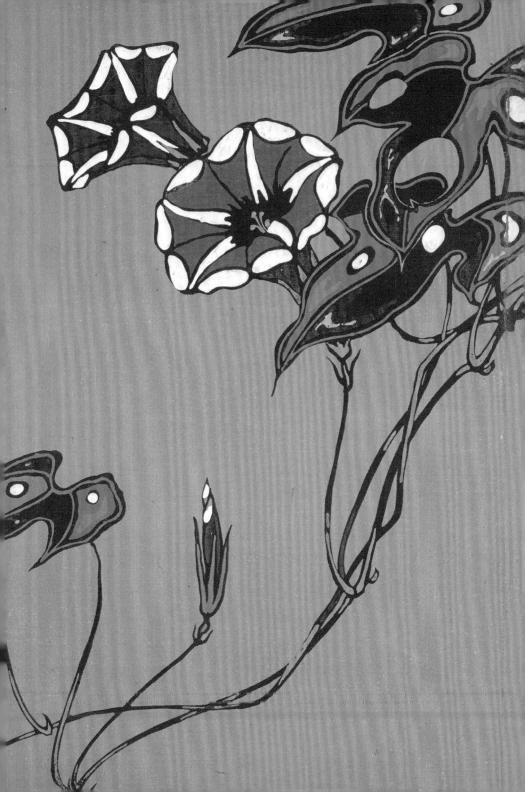

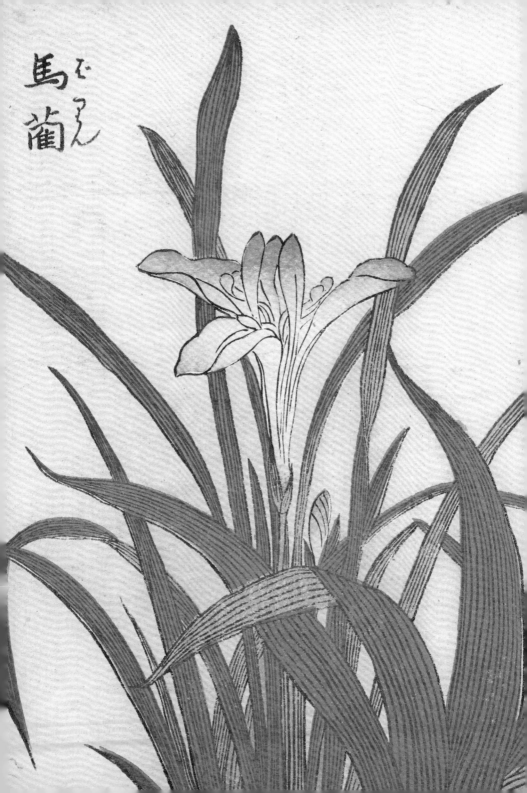

馬
藺
ば
れ
ん

Iris

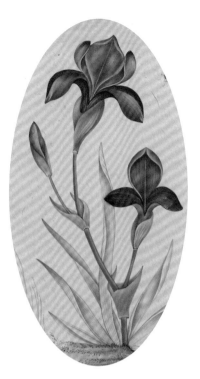

Bearded iris, *Iris germanica* (right), the most familiar iris in European gardens, also grows across Asia as far as India and Nepal. It was probably first cultivated in Egypt, where the flowers were carved in the temple of Karnak. The plants dot the landscape in Persian miniatures and feature in Mughal art. A scented variety, *I. florentina*, produced perfume from the dried rhizomes marketed as orris root, and a white variety, *I. albicans*, originally from the Yemen, was planted in Islamic cemeteries. In the Far East other iris species were cultivated which have a different profile – *I. kaempferi*, *I. laevigata* (opposite) and *I. ensata*. Their delicate petals spread out horizontally, they sport no beards and their rhizomes grow in water. Hiroshige's famous print displayed them growing in the foreground of the water garden of Horikiri, the nurseries outside Tokyo where many shades of colour were developed (and from the 1870s exported to the West). During the Japanese iris festival, as described in Sei Shonagon's tenth-century *Pillow Book*, 'there is not a place from the imperial palace to small cottages where people do not cover their roofs with iris leaves and artemisia. Iris roots in white paper are given as gifts and little girls wear the flowers in their hair'.

Jasmine

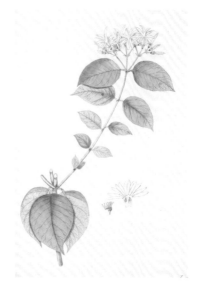

Many species of jasmine grow wild in the mountains of western China, and such centres of diversity normally indicate the origin of a genus. The two best-known imports to Europe are the yellow winter jasmine *Jasminum nudiflorum* (opposite) and the white *J. officinale*. The latter is the only scented jasmine to adapt readily to cultivation in Europe, where it was first described in Boccaccio's *Decameron* in 1348, perfuming the walks of a garden. The more heavily perfumed jasmines, *J. grandiflorum* and *J. sambac*, were always associated with Persia and the Arabic trade. In China, the third-century botanical treatise written by Chi Han said jasmine came from western Asia along the southern seas, and records from the later Tang dynasty associated jasmine with Byzantium and the Islamic world. The Chinese name *yeh-hsi-ming* is evidently linked to the Persian *yasaman*, as it is to jasmine. Where the plants that produce this fairy-tale scent first grew remains uncertain – we know only that it continuously crossed Asia as a fabulous commodity. It is hard to believe it was not Chinese originally, because the Chinese have made jasmine peculiarly their own, in gardens and plantations from Guangzhou to Beijing, plucking buds by the million to produce jasmine tea.

オーバイ

迎春花
ゲイシュンクワ

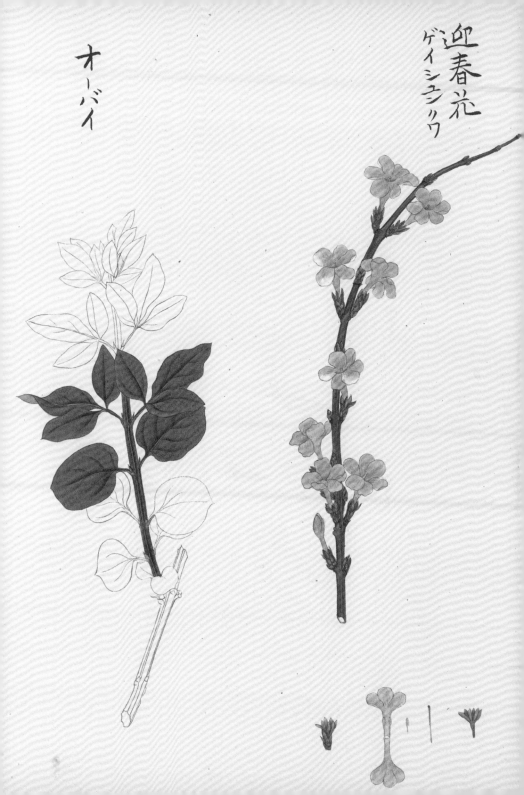

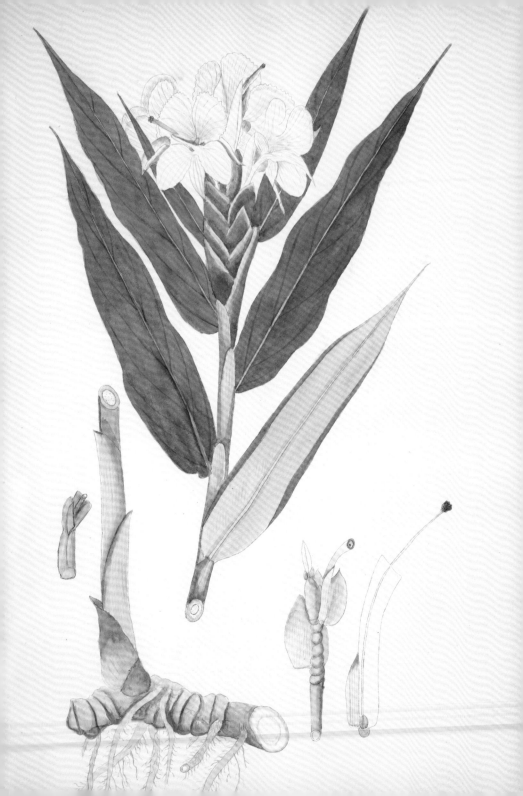

Ginger lily (white)

No member of the ginger family can equal the spicy pungency of ginger itself, its name anglicised from *Zingiber*, which in turn echoes Indian, Arabic and Greek names. The other related spices with knobbly, aromatic roots are turmeric *Curcuma*, cardamom *Elettaria*, ginger lily *Hedychium* and *Amomum* – all valued as condiments and/or scents, and all with strikingly handsome flowers. But the most beautiful of all these flowers belong to the white ginger lily – exquisite, long-lasting and hauntingly fragrant – which is well known across Asia as a cut flower. It is generally called *galangal*, Thai ginger or Chinese ginger, though these are loose inclusive terms. It has also been given various Latin names since its discovery, but the one that suits it best is *Kaempferia*. Engelbert Kaempfer, doctor and botanist, joined a Swedish embassy to Russia and Persia as far as the Persian Gulf, where he transferred to the fleet of the Dutch East India Company, sailing via India, Indonesia and Thailand and reaching Japan in 1690. There he stayed two years and on his return he published important early works on Japanese history and botany; *Kaempferia* was named in his honour.

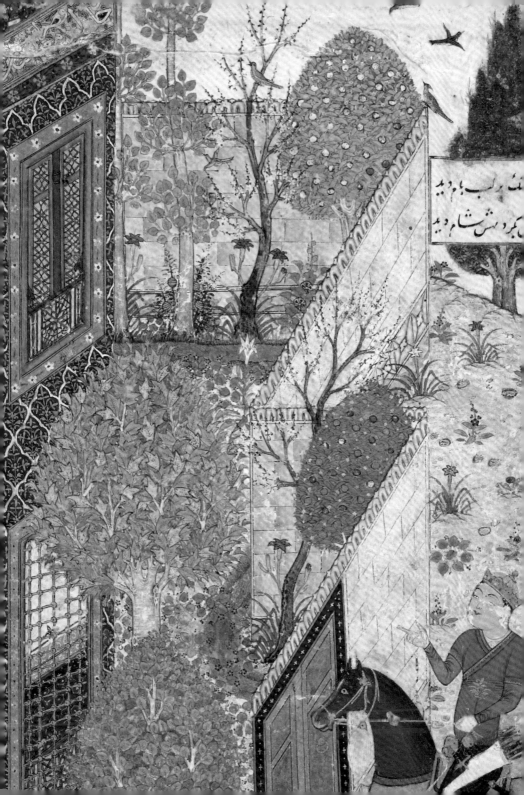

LILIUM

Lily

The love of lilies breathed, like their
perfume, over Cretan vases, along the
wall reliefs of Egypt and Mesopotamia
and into the *Song of Solomon*. Later
they graced Persian miniatures and the
golden borders of Mughal manuscripts.
The fourteenth-century *Khamsah*
of Kirmani told of a Persian prince,
Humay, falling in love with a portrait
of Humayan, a Chinese princess, and
setting off to find her. Arriving across
the wasteland he saw her in a high tower, surrounded by a walled
garden filled with blossom and lilies (opposite), like the Islamic
paradise. China and Japan enjoyed the greatest variety of wild
lilies, which they cultivated for their edible bulbs, until European
plant hunters unveiled the treasure store. The tiger lily, *Lilium
tigrinum*, known in China as rolled red and in Japan as ogre lily,
was sent to Kew Gardens from Canton (Guangzhou) in 1804 by
William Kerr. Philipp Franz von Siebold, collecting in Dejima,
introduced *L. speciosum* in 1830, described as 'all rugged with
rubies, garnets and sparkling crystal points'. Early in the twentieth
century E. H. Wilson, collecting for Veitch Nurseries, introduced
the most easily cultivated of lilies, *L. regale* (white and golden
inside, purple outside) and *L. henryi* (orange with brown spots).
Many more were to come, but these remain staple favourites.

Lychee

The story of the imperial concubine Yang Guifei is one of the great tragic romances of China. It inspired generations of poets and storytellers to detail her beauty and extravagance, and how she was finally strangled by rebels in front of the emperor's defeated army. The Tang poet Du Mu even made Yang Guifei's passion for lychees sound ominous: 'A thousand gates among mountain passes open each in turn / A single horseman in the red dust, and the young consort laughs / But no one knows if it is the lychees which come'. Yang Guifei became the concubine, entitled Precious Consort, of the eighth-century Tang emperor Xuanzong. The earlier years of his reign (when she was married to his son) had brought China to a peak of culture and power. But as poets imagined them making love on the palace terraces above the lotus pool, the court grew decadent and the administration fell prey to her relatives and favourites. One of her extravagant cravings was fresh lychees. She was said to wait in a watchtower as they were brought post haste by the 'single horseman in the red dust', from Guangdong province where they grew, in the distant tropical south.

Magnolia

Millions of years ago magnolias were among the earliest flowering plants, before bees existed, so they evolved with tough petals to be pollinated by beetles. Since magnolias first evolved, there have been ice ages and continental drifts, and so classifying their many species along normal geographical lines has baffled botanists. Asiatic magnolias, however, are the most varied and beautiful. They were introduced into Europe, later than the American ones, towards the end of the eighteenth century. First came the white Chinese species *Magnolia denudata* (flowering before the leaves) known in China as *Yulan*, meaning jade orchid. Then *M. liliiflora*, which has wine-dark backs to its petals. These became the parents of a major garden hybrid, *M. soulangeana*. Many others have since arrived, huge trees with pink flowers such as *M. campbellii*, or dainty shrubs with starry white flowers such as *M. stellata*, from the slopes of Mount Fuji in Japan. Chinese men of letters compared the flowers to other precious things, such as lotuses or jade. An admiring quotation, suitable when viewing magnolias, was 'wealth and position in halls of jade', or the Tang poet Wang Wei's (701–761) description, 'Lotus flowers on branches' tips / Send vermilion through the hills'.

Apple

The edible apple, *Malus domestica*, is descended from a wild apple of Central Asia, *M. sieversii*, which grows beyond the northern slopes of the Tien Shan mountains in the Ili valley of Kazakhstan. The valley is about 970 kilometres (600 miles) north of Almaty, which means 'place of apples'. However, the greatest number of wild apple species (over twenty) grow in China, which suggests this was the real area of origin, although these have small fruit more like hawthorn, fit only for birds. Probably birds transported the seeds, millennia ago, and in the isolated Ili valley a juicier fruit developed, attractive to horses, deer and camels. By natural selection the fruit grew larger and juicier, and the seed enlarged into a teardrop shape, with a hard coat and a dose of cyanide inside, so it would pass undigested through the gut of an animal and once again be transported. Humans also became involved in this distribution, possibly 6,000 years ago; along the network of routes later known as the Silk Road, apples and apple trees were traded both eastwards, back to China, and westwards, reaching Europe by the time of the Roman Empire. By grafting them onto native apple rootstocks (such as the crab apple, *M. sylvestris*) the Romans introduced sweet apples throughout Europe.

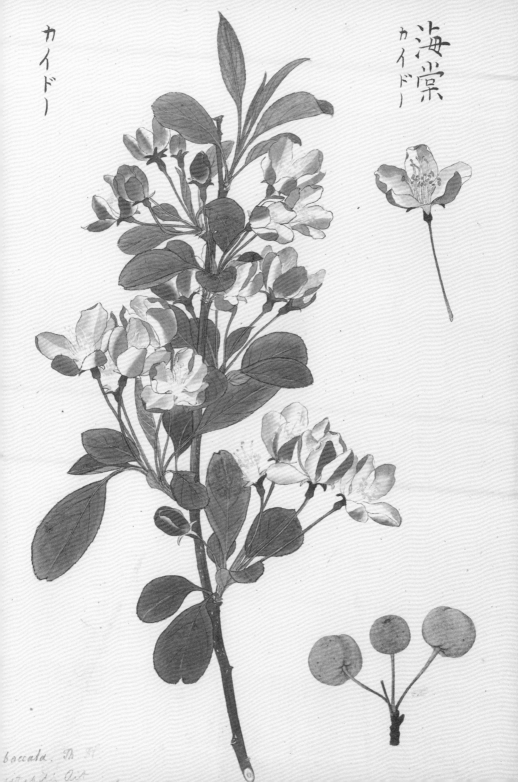

カイドー

海棠
カイドー

baccata. Ph. 31

Mango

Mangoes are redolent of India. 'May is a hot and brooding month ... the river shrinks and black crows gorge on bright mangoes in still dust-green trees' (Arundhati Roy, *The God of Small Things*, 1997). The Hindu gods sat under mango trees, especially Shiva, Parvati and their elephant-headed son Ganesh. The idea that mangoes are the food of love goes back to the Sanskrit Vedas, where Kama (the Indian Cupid) shoots flower-tipped arrows, and those bearing mango blossom are especially potent. At weddings and Hindu festivals, mango leaves are hung as auspicious decorations, folksingers recall the cuckoo singing to the mango 'Come my beloved', and storytellers delve into mango legends to provide the entertainment. Once upon a time there was a radiant princess, daughter of the sun, with whom a king fell in love. But a jealous sorceress turned her into ashes, from which grew a tree with fruit as radiant as the princess. The king plucked one and before him once again stood his princess. Every Indian rajah wanted a mango orchard in which to relax and dally. Buddha also had a mango grove, in which he meditated, and possibly it was Buddhist monks who carried mangoes to eastern Asia.

Singapore rhododendron

This lovely weed, a shrub with large purple flowers and silky branches, populates disturbed land, springing up among crops and grassland all over the Asian tropics. Its invasive quality may be turned to advantage by its use in phytoremediation, meaning that it is a plant able to absorb contaminants from the soil, rendering them harmless and gradually restoring to health land that has been polluted by chemicals. Melastoma is an accumulator of aluminium. Its common name, Singapore rhododendron, is misleading; it is not related to rhododendrons and its geographical range is wider than Singapore. The Latin name *M. malabathricum* (meaning Malabar melastoma) is similarly too confined, though it indicates how the plant was first named by Linnaeus from specimens brought back from the Malabar coast of India. Traditionally melastoma was used for food, the leaves eaten as a vegetable and the fruit, which bursts open when ripe, made into a sweet black pulp. This stains the mouth black, and it can also be processed as a dye. Medicinally, it is an astringent and is used to treat dysentery and wounds; and in Malaysia the rare appearance of a white melastoma flower is considered magical.

Mulberry

There are three species of mulberry: white, indigenous only to northern China; black, from western Asia, but widespread; and red, indigenous to America. The white mulberry *Morus alba* is the only food on which silkworms thrive and produce fine thread; obviously they too are indigenous only to China. The white mulberry is a medium-sized tree (easily propagated from cuttings) which was grown on every smallholding in China, causing many poets to evoke mulberry plantations in the landscape. In the wild the fruit is deep purple, like other mulberries, but in cultivation it has become pinkish-white and too bland to be tasty. The silkworm larvae feed on the leaves and, as they pupate, spin a protective cocoon from which can be drawn a thread several hundred metres long. Sericulture can be traced back for at least 5,000 years in China, and gradually reached Korea, Japan, India and Persia, even though the penalty for exporting silkworms was death. The Elder Pliny was the first European to record that silk came from a moth 'spinning a web like a spider', and there were daring stories of smuggling silkworm eggs from China to Byzantium. But the silk trade continued to depend on China, even when Arab conquests spread attempts at sericulture to the Mediterranean lands.

Banana

Bananas are a fruit of tropical Asia, celebrated above all in Indian and South East Asian art as a lush backdrop to dancing gods, evoking fertility. In Islamic tradition, the forbidden fruit in the Garden of Eden was a banana, and European nomenclature acknowledged this heritage by adopting the Arabic name *Musa* for the genus and adding two specific names, *Musa paradisiaca* or *M. sapientum* (wisdom). The link with brainpower and knowledge has now been endorsed by research into the beneficial chemicals in bananas, including potassium and dopamine. In China and Japan bananas arrived from the subtropical south and were again linked with scholarship. The sound of raindrops on banana leaves became an allusion to the philosopher-poet in his hideaway, musing and writing. In Chinese gardens apt quotations carved on rocks recalled this association. The seventeenth-century Japanese poet Basho, famous for his haiku, took his *nom de plume* from the Japanese word for banana – planting one beside his hermit's hut and writing: 'Wind tossed banana leaves / An autumn night / Rain dripping in a basin'. More cheerfully, one of his followers responded: 'A tree frog / Clinging to a banana leaf / And raindrops pattering'.

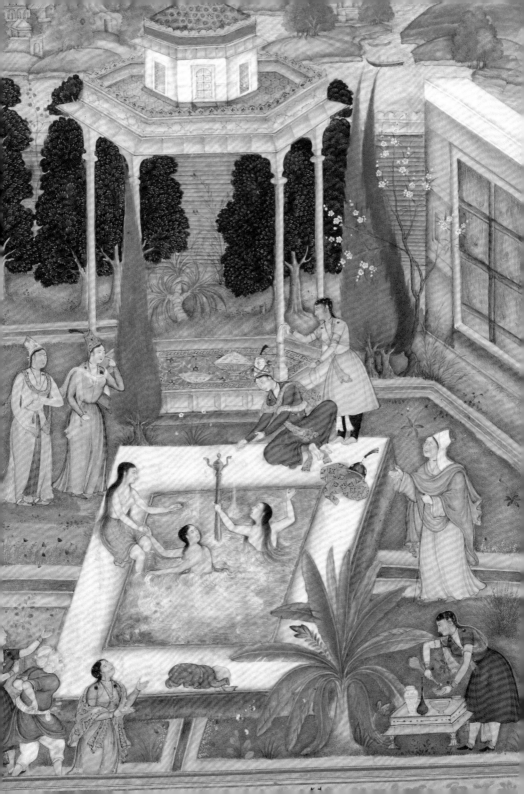

Narcissus

The narcissus that has spread furthest across Asia is *Narcissus tazetta*, named for the tiny golden cups set amidst paper-white petals (pictured here; it is also growing, along with tulips, in the orchard pictured on page 179). Like most species it grows in Mediterranean countries, but also across Persia and Kashmir as far as China and Japan, happy only in warmer regions. The word 'narcissus', like 'narcotic', comes from the Greek for sleep, because the bulbs contain a substance akin to opium, and even the smell was thought to induce a heavy, dream-like state. This was the predicament of Narcissus gazing in the pool in Greek legend, and in Persian and Mughal literature, where its name is *nargis*, the eye of the flower was always described as languid or intoxicated. When narcissi arrived in China, probably during the Tang dynasty (618–906), they were described as a flower from the West, where Byzantine emperors anointed themselves with their perfumed oil. At first *nai-chi* echoed the Western name, then they became sacred Chinese lily, water-fairy flower or New Year lily – because during Chinese New Year the flowers are forced in special pots of water and pebbles. Far from such convivial celebrations, Basho wrote a haiku on quietness – simply describing a white narcissus against a white paper screen.

Lotus

The lotus *Nelumbo nucifera* is the most sacred flower of the East, compared in religious texts to the purified human spirit rising above the muddy waters of life's desires. In Hindu iconography, many deities were portrayed enthroned on lotus petals. Vishnu, Preserver of the Universe, rested with his consort Lakshmi on the cosmic snake, who first churned the primordial mud to recreate the world. A lotus grew from Vishnu's navel and on it Brahma, Creator of the Universe, was seated (see overleaf). Buddhism inherited the religious symbolism of the lotus, making it the flower of enlightenment, reaching above worldly attainments and opening its petals like an expanding soul. Chinese Daoist philosophers also advocated detachment by quoting the adage 'as the lotus flower is untouched by muddy water'. The plant is also edible in a variety of ways: the root is sliced as a vegetable or pickled; the seeds are ground into a sweet paste, an ingredient of mooncakes; the young leaves or petals are infused in teas. So it is not only the gods that float among the lotus petals, but also the harvesters of everyday necessities, as depicted in the Kashmir Album (see overleaf).

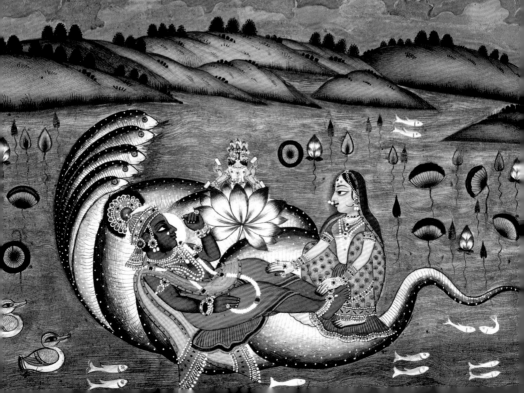

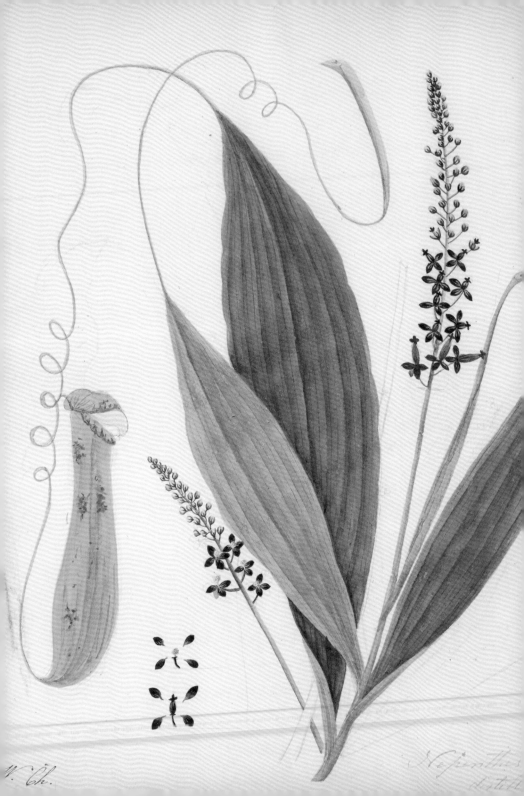

W. Ch.

Nepenthes
distil...

Pitcher plant

Nepenthes, or pitcher plants, occur in remote jungly areas from southern China to Madagascar, with the greatest diversity in Borneo and Sumatra. Pictures and descriptions reached Europe long before the plants themselves. The Dutch botanist G. E. Rumpf was the first to explain, in 1692, that the nectar in the pitchers was designed to lure and trap insects, but Linnaeus named nepenthes after a Homeric potion that quelled all sorrows. Hugh Low, under the patronage of Rajah Brooke in the 1840s, discovered eight species, including *Nepenthes hookeriana*, named after the Director of Kew, and his own namesake *N. lowii*, which provides perfect dimensions for a tree shrew to perch, while drinking the nectar and simultaneously defecating into the pitcher, thus providing most of the plant's nourishment without dying in the process. As the Victorian fashion for hothouse exotics intensified, so did the efforts of collectors. Charles Curtis landed in Sarawak in 1878, anxious to find a pitcher plant known only through a painting by Marianne North, who had no idea where it grew since it had been brought to her. When he succeeded he graciously named it *N. northiana*.

NERIUM

Oleander

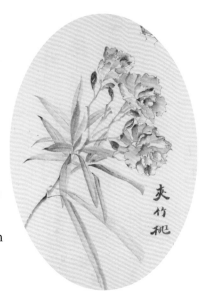

The oleander (*Nerium oleander*)
originated in Persia but long ago
became widespread. The Greek
botanist Theophrastus (c. 330 BC)
described a plant with leaves like
an almond and red flowers, which
he recommended mixing in wine
as a sedative; but since one leaf
would have been a fatal dose, he
cannot have known it well. The first Chinese record was from the
southeastern coastal province of Fujian in the fourteenth century,
suggesting it arrived by the sea route. The Mughal emperor Babur
also transported oleanders, noting in his memoirs: 'those of
Gwalior are deep red, I took some to Agra and had them planted'.
Some believe that even the exhalations of oleanders are harmful,
and in Chinese literature they have become linked to omens
predicting death and the hauntings of departed spirits. Chi Yun,
the eighteenth-century author of *Notes of a Confucian Scholar*,
described how his concubine Ming Kan wrote a poem about the
moonlit shadows cast by the oleanders outside their bedroom
window: 'In three places the dancing blossoms are as if one /
Except in two places, sadly, they are only shadows of flowers'.
But, wrote Chi Yun sadly, the following year she and her maid died
while he was away at the Summer Palace – the deaths ominously
foretold by those two shadows.

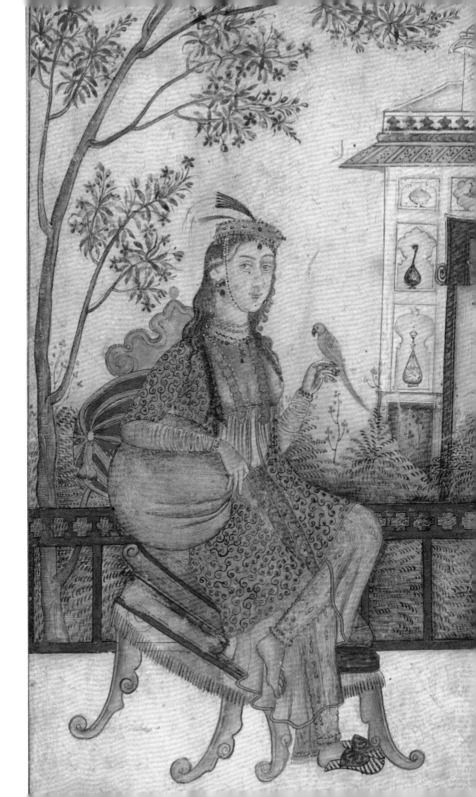

Orchid

The orchids of Asia are designed to fascinate, but the objects of their own desire are pollinators, not humans. Slipper orchids have pouches curiously like fancy shoes (*Cypripedium japonicum*, opposite) in which exploratory insects are trapped, capturing pollen as they seek the way out, and depositing it in the next enticing slipper that they visit. Dendrobiums, with their large tubular flowers hanging from tree branches (below), need sunbirds seeking nectar to do the trick. Other orchids mimic the females of the insects they wish to attract, and exude a pheromone which excites pseudo-copulation, during which the insect fertilises flowers rather than its own species. In another deception, certain orchids mimic male insects, especially wasps, and achieve pollination during mock battles. The spider orchid of Malaysia and Indonesia, *Arachnis flos-aeris*, would seem to be designed for such a purpose, and has a suitably musky smell, but its pollinator is still unknown. Until European collectors succumbed to their charms, orchids thrived. Epiphytes such as dendrobiums and arachnis (overleaf, right) dangled in the rainforests; massive colonies of cymbidiums opened their fan-like leaves on the mountain slopes of Japan; and the Chinese left their tropical orchids, such as bletillas (overleaf, left), undisturbed since they have no scent.

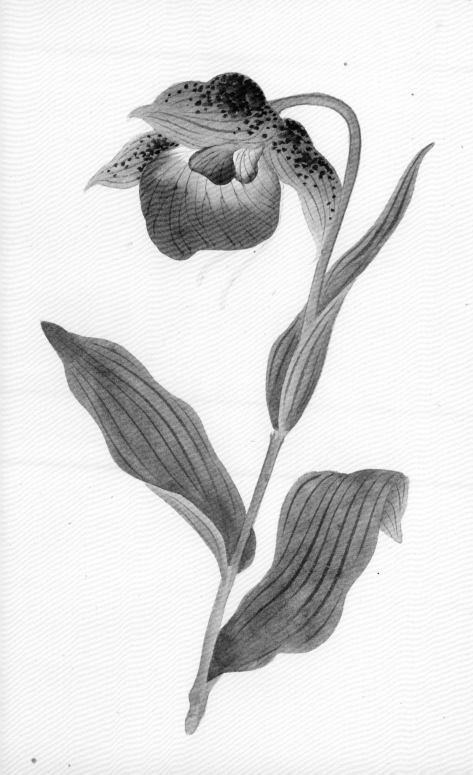

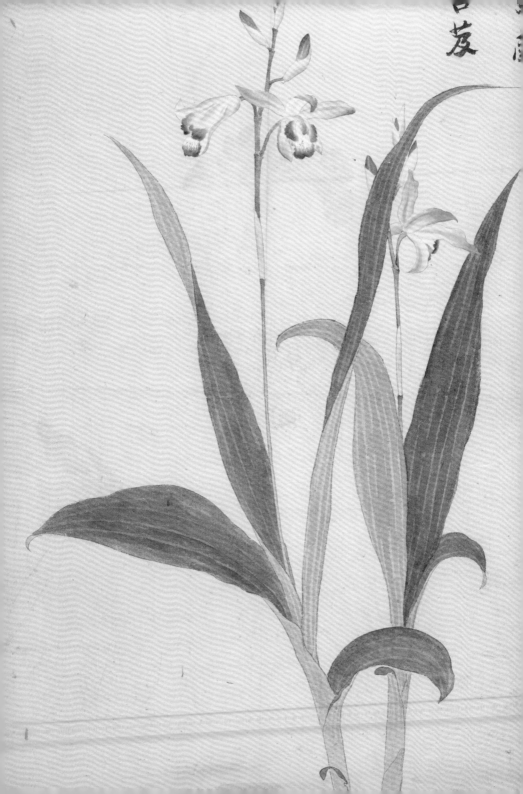

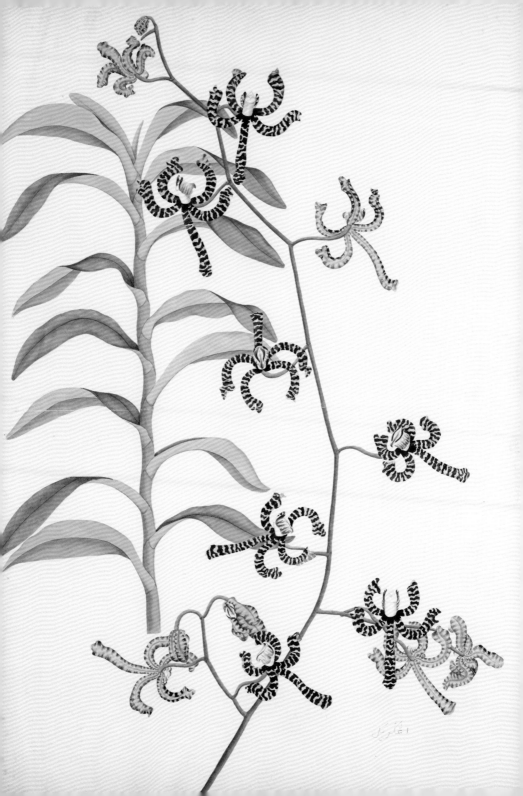

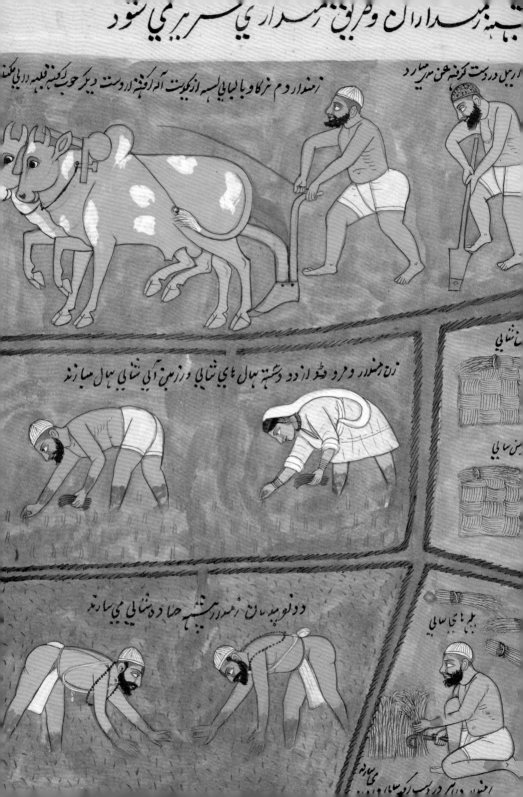

Rice

Rice, the staple food of Asia, was first domesticated in China –
the genes have been traced to their wild plant *Oryza rufipogon*.
From there cultivation spread across Asia, with different
hybrids and varieties adapting to local conditions, and rice was
introduced to the classical world under an Indo-Iranian name
which became the Latin *oryza*. Rice requires ample water, but
it can be grown in upland areas (such as Kashmir) with terrace
and irrigation systems. The rice fields are flooded while setting
the young seedlings, in the past often accompanied by rituals to
summon helpful divinities. In Thailand and Laos rockets were
let off to irritate the gods into sending plentiful rainstorms. In
Japan, when planting began, the Shinto god Inari, or his female
version Inara, was called to visit the rice fields in the form of a fox
or spider, tormenting the wicked. In Indonesia the first harvest
stalks were modelled into a bridal couple for the rice goddess
Dewi Sri, who was also goddess of the dead. In India, the Hindu
elephant god Ganesh has a good round belly because he is offered
so many sweet rice puddings, and Indonesian shadow puppets, in
deference to their ritualistic origins, are offered rice paste before a
performance. As a basic source of well-being, rice became a part
of wedding rituals in many cultures.

Peony

In China, early in the Tang dynasty, the tree peony *Paeonia suffruticosa* provoked an infatuation that never waned. (It was originally called *P. moutan* after its Chinese name: *moutan* means male/red.) The voluptuous flowers were associated with imperial splendour, and while attending the spring festivities in the peony garden of the Tang emperor Xuanzong, the poet Li Bai (701–762) composed these, oft-quoted, lines to the Precious Consort Yang Guifei: 'The glory of trailing clouds is in her garments / And the radiance of the flower in her face'. Similarly Li Shangyin (813–858) wrote: 'I wish to write on petals a message to the clouds of morning', and piled up peony metaphors such as 'embroidered quilts, fluttering saffron skirts, jade pendants, brocade curtains' and 'braziers where no incense fumes', alongside suggestive allusions to the Queen of Wei and Prince O in Yueh. Four centuries later Marco Polo gave the first European description of 'roses as large as cabbages' – aptly, because precious peony blooms were transported in bamboo cages lined with cabbage leaves. But it was not until the nineteenth century that oriental peonies arrived in Europe, thanks to Philipp Franz von Siebold in Japan and Robert Fortune in China, although appetites had been roused by the blooms depicted on Chinese porcelain and wallpaper.

野芍藥

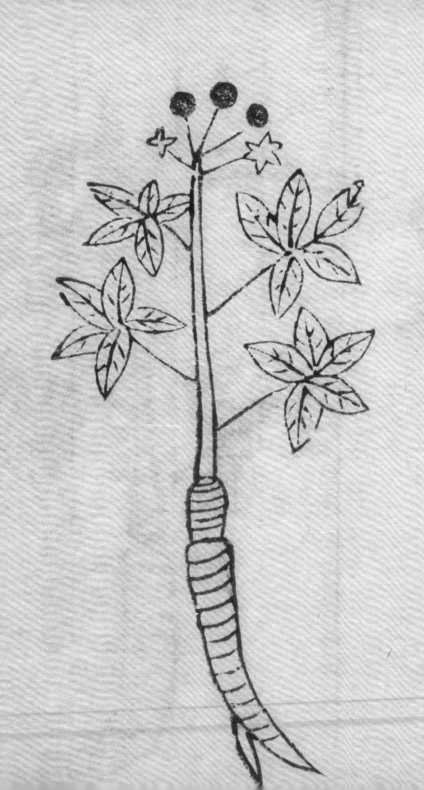

Ginseng

The root of ginseng may not have magical qualities (indeed, its efficacy has not been confirmed by clinical trials), but as a tonic it promotes healing – for those who believe in it – by soothing stress and raising energy levels. Possibly it acts by causing the body to release seratonin and dopamine. In classifying ginseng, Linnaeus recognised its reputation with the generic name *Panax*, as in panacea, because in the Chinese pharmacopoeia ginseng has been paramount for centuries. There are several species (not to mention substitutes). The indigenous Chinese *Panax ginseng* now has enormous rarity value; *P. pseudoginseng* is native to Korea and Manchuria; and the North American *P. quinquefolius* is cultivated mainly for the Chinese market. The Chinese name is *renshen*, literally 'person root', since it forks at the base like little legs. White ginseng is produced when the root is peeled and dried, red ginseng when the skin (containing red resin) is left on and the root boiled. The plant needs rich soil, warmth and shade and is distinguished by a cluster of red berries. The root takes six years to mature – an unconscionable time in a crop; until then its active elements are not sufficiently concentrated.

Poppy

Opium poppies, *Papaver somniferum*, were spread all across the ancient world, being deeply valued for their pain-killing properties; and red field poppies *P. rhoeas* spread anyway. Bright poppy flowers appear in most Eastern art, enhancing the barren background landscapes of Persian miniatures, the stylised pages of Arabic herbals, and the golden borders of Mughal manuscripts, while cultivars with double flowers and mixed colours appeared in albums of flower paintings from Turkey to Japan. Opium is not present in the poppy seeds themselves, which are used to spice food and produce oil; it is gathered from the latex exuded by the green seed capsules of *P. somniferum* – emphasised darkly by the illustrator of one fourteenth-century Arabic herbal (below). The danger of opium was understood, but its destructive power only became fully evident when it was used recreationally, and Europeans used the Indian crop as a commodity to open up trade with China. Earlier, a haunting suggestion of the power of poppies was carved over the entrance gate of the Ghulabi-bagh in Lahore, created in 1655: 'What a pleasant garden, a garden so beautiful that the poppy is burnt with a spot of desire'.

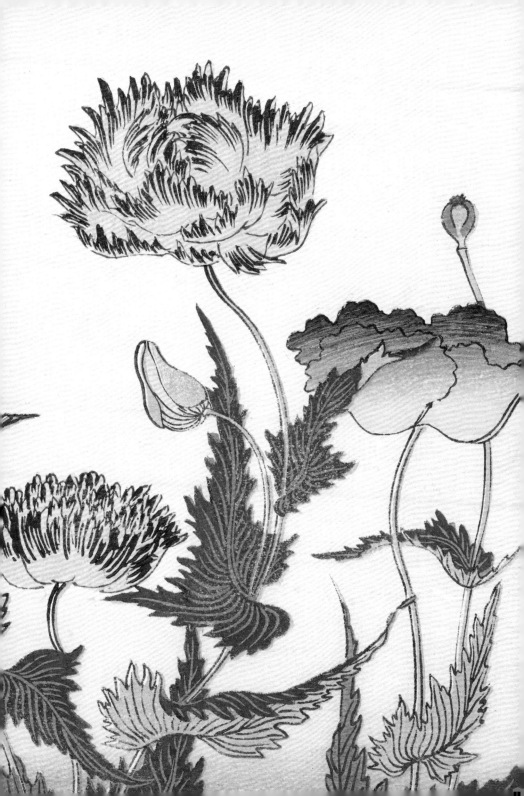

10

白桐 ハクトウ
キリ

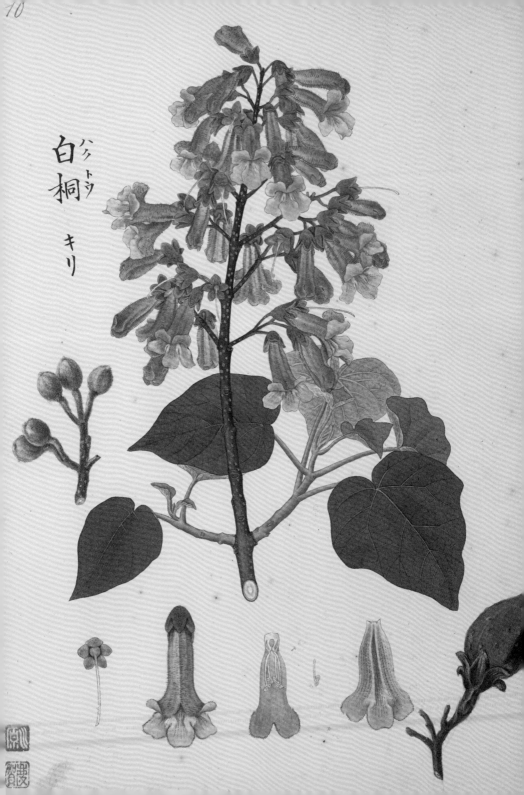

Paulownia

Paulownia is a beautiful tree, tall and drought resistant, with large heart-shaped leaves and clusters of mauve-spotted tubular flowers (earning its nickname, foxglove tree). The Chinese name is phoenix tree – perhaps because it grows at an astonishing rate and regenerates when felled, as the phoenix is reborn when it is immolated – but there is also a legend that a phoenix would land only on paulownia branches. Paulownias are planted as ornamentals and shade trees, fodder for cattle and nectar for bees. The wood is light and strong, silky smooth and resistant to water and warping – valued for boats, furniture, clogs and especially musical instruments, from the zithers of the Tang dynasty and the Japanese koto, to modern electric guitars. Paulownia sawdust was used to pack fireworks, and the winged seed cases provided packaging for porcelain. When a baby girl was born, a paulownia was planted and its wood used for her dowry chest and other furniture. Although paulownias have been cultivated in the East for thousands of years, their scientific name was given by Philipp Franz von Siebold in honour of Queen Pavlovnia, wife of William II, who ruled the Netherlands when Dejima was the only trading settlement in Japan.

Palm

Palms around an oasis pool are the archetype of all Islamic gardens, and of paradise itself. The first muezzin, before minarets existed, climbed a palm tree to call the faithful to prayer. And the storytellers of the Arab world – around oasis campfires, in caravanserais, or like Sheherazade beguiling a murderous potentate – described romantic trysts in the shade of palm trees or set spies among their branches. Palms have myriad uses for nourishment, oil, fibre and shelter, though the Mughal emperor Babur, when assessing the merits of Indian trees, dismissed palm wine: 'no hilarity was felt, much must be drunk seemingly to produce a little cheer'. In a tale of Nasruddin, the legendary Sufi trickster, he and his companion were lost in the desert until at last they found an oasis between two huge sand dunes, rich with palm trees, green grass and lovely flowers. Thanking Allah with all their hearts they rushed down to the pool, took huge gulps of water and bathed their weary feet. Suddenly a lion roared from the dune above them. Nasruddin grabbed his boots and began putting them on, while his companion ran off, saying, 'You fool, do you think with boots you can run faster than a lion?' 'No,' said Nasruddin, 'I only need to run faster than you.'

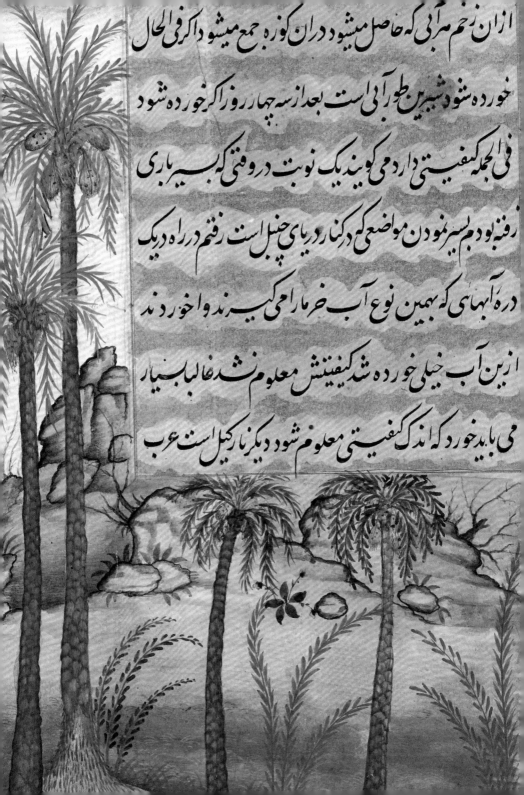

ازان زخم شرابی که حاصل میشود دران کوزه جمع میشود اکرفی الحال

خورده شود شیرین طرآبی است بعد از سه چهار روز اگر خورده شود

فی الجمله کیفیتی دارد می گویند یک نوبت در رفتی که بسیار باری

رفته بودم بسیر نمودن مواضعی که در کنار دریای چنبل است رفتم در راه در یک

دره آبهای که بهین نوع آب خرما می کیرند و خوردند

ازین آب خیلی خورده شد کیفیتش معلوم شد غالبا بسیار

می باید خورد که اندک کیفیتی معلوم شود دیکر نارکیل است عرب

y Cordiall ware Medicines Might be Made of itt as or
such lik

the Chank beron tree
or ... y peps ...
abour

the
peps
is
growing
about
y chank
tree. —

... into 3 Sorts becaufe of its differinge y ett onely one differ
... with and age, the younger part the leaues be more longer, and narro
fuller of ... the Elder ... the leaues are ...

PIPER

Pepper

Peppercorns grow on a perennial climber (seen here draped over a thorny supporting erythrina tree), with long clusters of red berries that yield peppercorns. Many species of pepper grow across the tropical world, but *Piper nigrum* from southern India became more widely consumed than all other spices. In the Roman Empire it was referred to as black gold, and demand caused its cultivation to spread all through South East Asia. In medieval Europe, Italians monopolised the pepper trade after it crossed the Arab world and its price was a major stimulus to Europeans searching for sea routes to the East. This naive illustration and description were produced somewhere in the East Indies, early in the seventeenth century, by an English traveller who described the uses and medicinal properties of local plants. The wrinkled red berries, each containing one seed, are harvested just before they ripen and before losing their pungency. For black pepper they are boiled and dried till they blacken. For white pepper the berry is soaked and removed, leaving only the pale seed. Green and red peppercorns have been pickled.

Chinese bellflower

The Chinese bellflower, a large and beautiful campanula, is usually the deep blue of a darkening sky, but may also be pink, and in Korea the white variety prevails. As a widespread wild flower it became the stuff of folksong and emblems (for instance on the clan flags of Japan). It can sometimes be discerned in traditional pictures of Japanese gardens. The tap root, of which the main chemical constituent is saponin, is used as an anti-inflammatory, but may also be substituted for ginseng, the greatest panacea of all. It is also eaten as a potherb, and in Korean cuisine, where it is called *doraji*, it is ubiquitous – pickled, honeyed or processed into tea or alcohol. The English name balloon flower describes the swelling shape of the unopened bud, while the name 'blew bellflower of China' was used, inexplicably early, by John Gerard in 1599. Robert Fortune brought it to England after his first voyage to China in 1846; and James Harry Veitch, travelling for the family nursery in 1892, described platycodon in all its wild blue glory, growing on the lower levels of Mount Fuji 'common as buttercups'.

キ　キョウ

桔梗

キ
キョウ

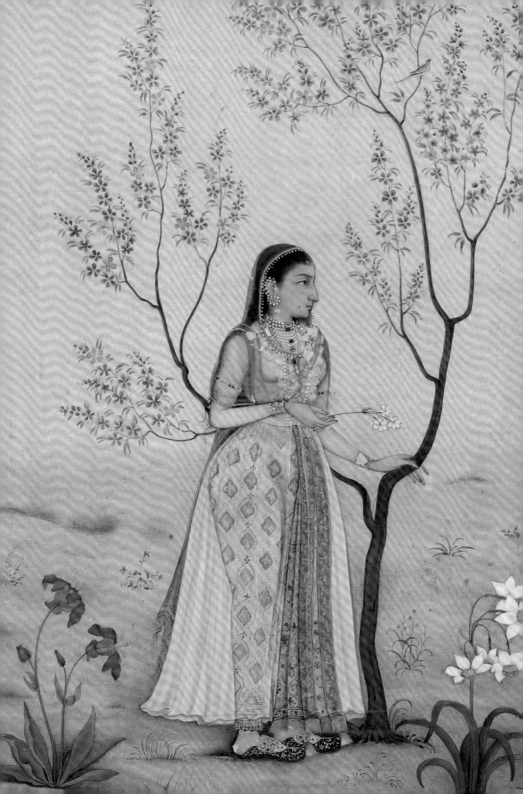

Plum, cherry, peach, apricot, almond

The genus *Prunus* includes most of the loveliest blossom trees of springtime and their fruits – plum, cherry, peach, apricot and almond – and all are of Asiatic origin. As the harbinger of spring, the early white flowers of *Prunus mume*, known as *meihua*, Chinese plum or Japanese apricot, were much praised and painted, always ethereal and sometimes touched with snow. Festivals for viewing *meihua* were held all over China in beauty spots such as the West Lake of Hangzhou. Originally the Japanese favourite was also *P. mume* but, in the ninth century, cherry blossom, *sakuru*, became and remained the prevailing fashion. Cherry trees bloomed as spring grew warmer and picnics could be taken in their shade – as Basho obviously did: 'Under a cherry tree / Soup, salad and all else / Dressed in pink blossoms'. In China, peaches were mythologised as the fruit of the immortals, growing in the garden of the Queen of the West, while in India they were called *cinani*, meaning 'from China', whereas in fact the finest peaches were probably developed in Samarkand and the Persian Empire. Among all the poetic allusions to fruit blossom, apricot blossoms symbolise the teachings of Confucius, who taught his disciples in an apricot orchard.

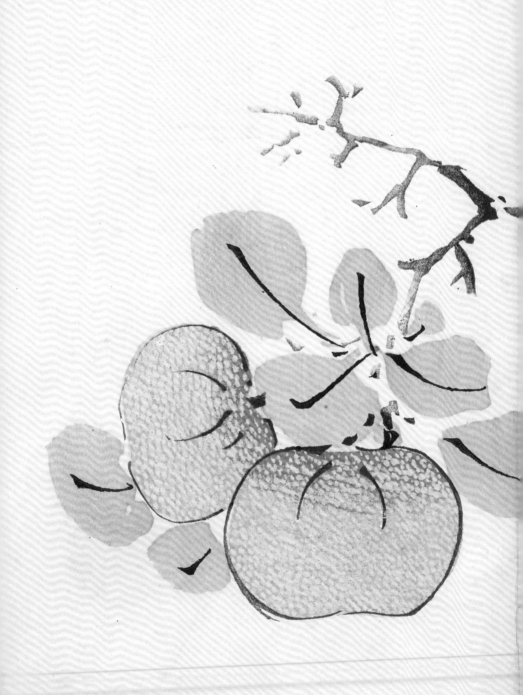

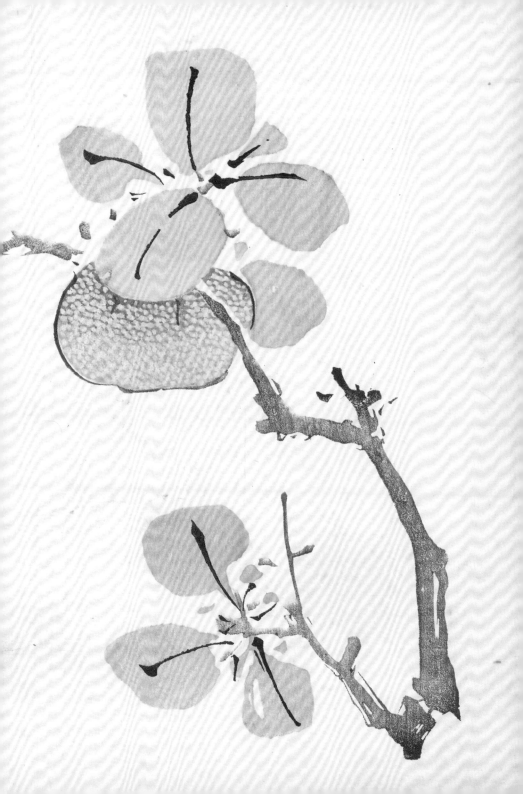

Pomegranate

'One hundred rubies sitting side by side' is a riddling song from Persia, and nothing could better encapsulate the appeal of this curious fruit, so full of jellied seeds, which has signified fertility and prosperity to every civilisation encountering it. There is evidence of pomegranates in cuneiform tablets and Egyptian tombs, and their association with ancient goddesses was inherited by the Greeks, who spun the best pomegranate legend of all about Persephone's descent to the underworld, the forfeit she paid by eating pomegranate seeds (another forbidden fruit) and her resurrection for the fertile half of each year. In Turkey the New Year was greeted by smashing pomegranates on the floor; while on her wedding night an Armenian bride would hurl a pomegranate against the wall, to scatter the auspicious seeds. From the land of their origin in Persia pomegranates travelled eastwards, thriving in Afghanistan (they appear in the foreground of miniatures of

Babur's garden in Kabul, the Bagh-e wafa), first arriving in China during the Tang dynasty (618–906), and thence to Japan and Korea.

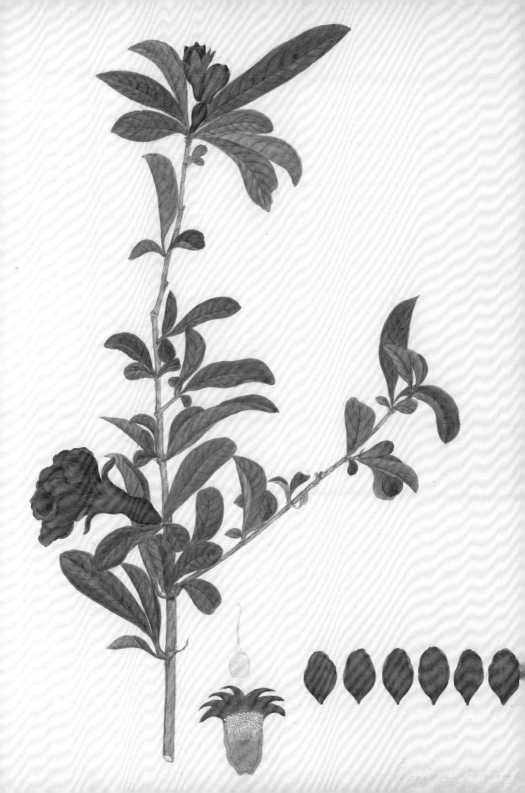

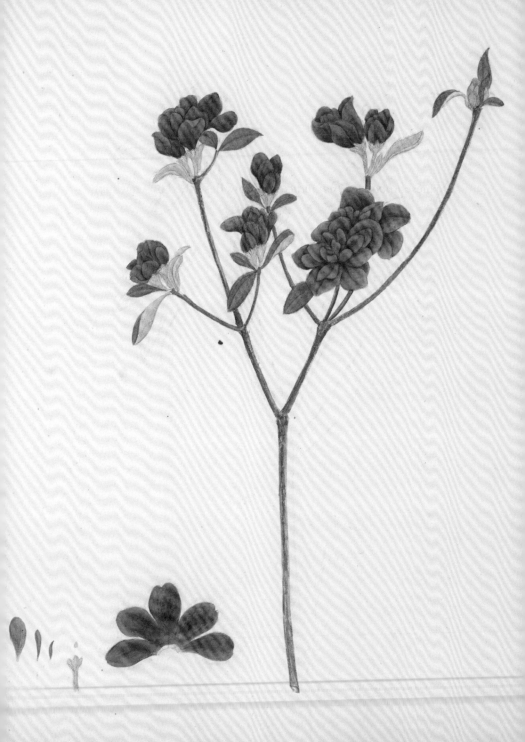

工托雙　　71　1

Rhododendron, Acacia

When Linnaeus classified rhododendrons in 1753 (including the Japanese *Rhododendron indicum*, below, described by Engelbert Kaempfer in 1712) he named azaleas separately, which was a mistake, because they interbreed and the main distinction is that rhododendrons are evergreen and azaleas are deciduous. The first rhododendrons reached Europe from America and the Levant, but the finest grow in the Himalayas and remote mountains of western China. The blood-red *R. arboreum* arrived from the Himalayas in 1796 (Thomas Hardwicke 'liberally distributed the seeds to enrich our collections'), but being tender it served best as a magnificent parent in the hybridising craze that soon hit collectors. From 1848 to 1850 Joseph Hooker, later Director of Kew, travelled far into the Himalayas to become the most famous collector of all. In 1856 Robert Fortune, exploring from Shanghai, collected *R. fortunei* (its mauve-pink flowers known to the Chinese as 'cloud-brocades'). Rhododendrons had long been cultivated in China and Japan: rosy-purple *R. pulchrum*; fragrant white *R. mucronatum*; yellow *R. molle*; and *R. simsii*, which covers the hillsides of the Yangtze and Pearl rivers, earning the name 'reflecting red mountains'.

Rhodomyrtus

Rose myrtle is a tropical version of the white-flowered myrtle indigenous to western Asia, bearing similar dark purple edible fruits and with a similar puff of stamens in the centre of its dainty flowers. It is a tough, bushy plant that, in favourable hot moist conditions, becomes invasive. Originally from Indo-Malaysia, it was distributed all across South East Asia, and was first described in Europe in 1705 from specimens found on Fujian island off the Chinese coast. Rhodomyrtus earned a place among the natural history illustrations collected by such connoisseurs as Governor General Wellesley (older brother of the Duke of Wellington) in Calcutta, Sir Stamford Raffles in Indonesia and Philipp Franz von Siebold in Japan. When Siebold was expelled in 1829 on suspicion of being a spy, he was still able to export living plants, books and maps. But most precious of all were the botanical drawings by Japanese artists, from which were produced the coloured plates for Siebold's *Flora Japonica*, published 1835–42.

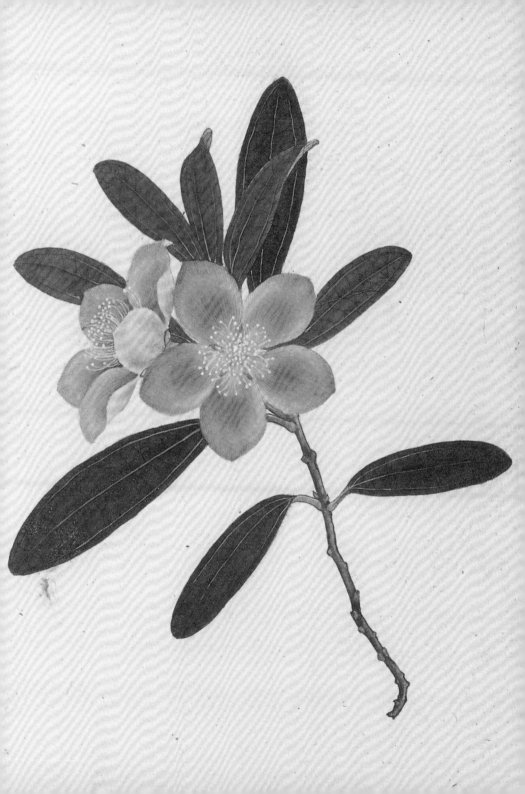

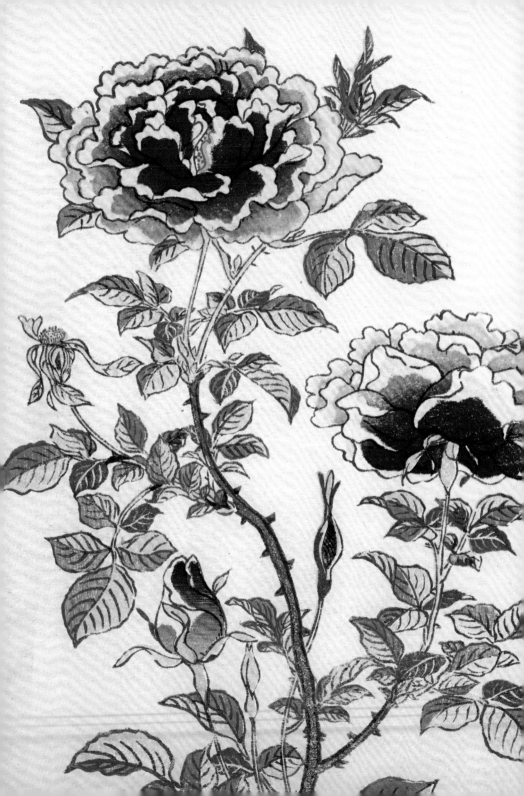

ROSA

Rose

Roses are not exclusive to
the East, but some of their
best features are, especially
the repeat-flowering habit
which extends their season
beyond the ephemeral burst
characteristic of European roses.

The repeat-flowering China rose, *Rosa chinesis*, was introduced by the
East India Company in the eighteenth century (confusingly named
R. indica or the Bengal rose), to be followed by tea roses, hybrids
from the plant nurseries of Canton. Also, all climbing roses and
yellow roses come from Asia. First came the climbing musk rose
R. moschata (originally from the Himalayas); the vivid yellow/
orange *R. foetida* from Persia, and the damask rose *R. damascena*,
from which perfumed oils (attar of roses) were first extracted
in the Middle East. Many other oriental species contributed to
European hybrids, such as *R. multiflora*, ancestor of rambling
polyanthus roses. The most intense red arrived when *R. moyesii*
was discovered on the Tibetan border; the finest hips when
R. rugosa was introduced from Japan by Philipp Franz von Siebold.
The East also offered rose poetry: either amorous, like the verses of
the Persian poet Hafiz ('The red rose is open and the nightingale is
drunk'); or transcendent, like Sufi poetry ('How long is the life of a
rose? The bud just smiles').

Sugar

Cane sugar is derived from the stout jointed stalks of a grass named saccharum, which grows up to 6 metres (20 feet) high and stores sucrose in the internodes of the stalks. Many species of saccharum are indigenous to southern Asia and were developed locally, until the cultivars became complex hybrids. The primitive method was to chew sugarcane, then early boiling processes produced caramel, and the first refinement of crystalline sugar took place in India. Through Persia the Sanskrit name *sakcharon* became known to the classical world as 'reeds that produce honey without bees'. During the eighth century, Tang China sent missions to India in search of 'sweet frost', and, with the expansion of Islam, sugar cultivation spread around the Mediterranean. Sugar cane was among the first crops to be taken by Spain and Portugal to their South American colonies to establish plantations; the Dutch, French and English followed suit and the development of the slave trade ensued. The search for better cultivars also continued. William Roxburgh in Calcutta investigated *Saccharum sinense* from Canton, thinking it might prove 'higher in yield and less subject to pests (jackals and white ants) than our Bengal sort'.

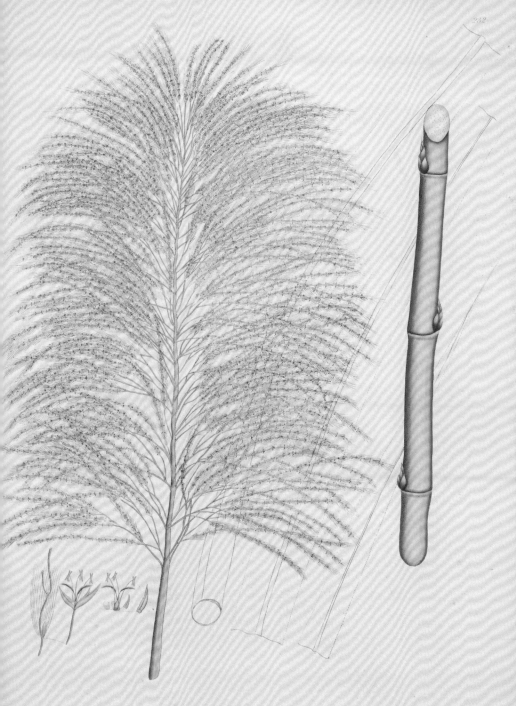

Saccharum sinense

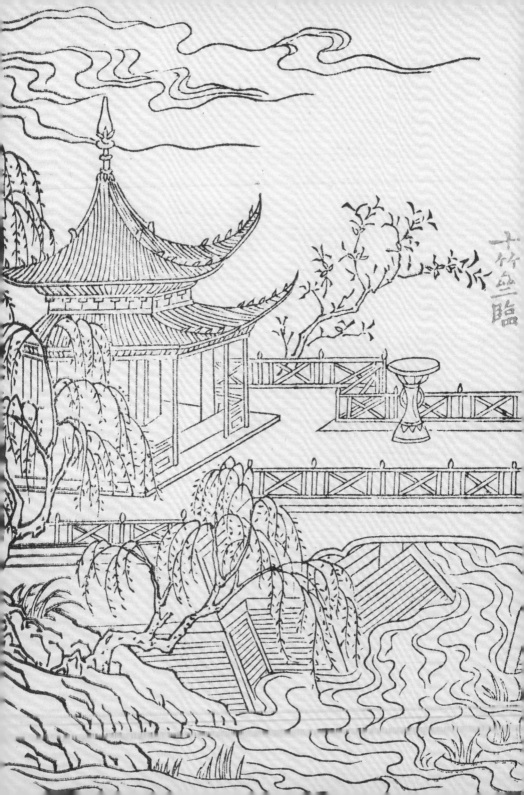

SALIX

Willow

Long before the motif was borrowed for willow-pattern plates, Chinese artists used willow for its graceful calligraphic quality. In Persian miniatures, willows fitted the artistic principle of contrast and balance, spreading young leaves alongside a dark evergreen tree. In China the fluffy catkins of pussy willow signify the New Year celebrations. At first they resemble the white cocoon of a silkworm, then the ripening pollen dusts them with gold, and finally the young leaves emerge like precious green jade – all very auspicious tokens of prosperity. Willows overhanging water were a gift to poets and, in Japan especially, the very word willow was a homage to past masters. Basho searched for the particular willow tree which Saigyo had described five centuries earlier 'spreading its shade over a crystal stream'. He also had this revered heritage in mind when he discussed poetic imagery. For verses of a higher order he stated that describing a green willow in the spring rain would be excellent, while for verses of a lower order, made among friends, Basho suggested more homely images were needed.

Strophanthus

This typically tropical plant is a woody liana evolved to grow among rainforest trees, and was named for its striking spidery flowers with their purple corolla lobes – *stroph* means 'twisted cord'. The paired follicles of the fruit have earned the plant other names, such as goat horns, or *tandok-tandok* in Malay. Strophanthus plants climb to 30 metres (100 feet) or more and are pollinated only by insects that dwell in the treetops, mainly butterflies. About thirty species grow in Africa and seven in Asia, including *S. caudatus* (meaning 'purple'), shown here, which grows all across South East Asia from India to southern China. Strophanthus was valued by all primitive hunting societies as an arrow poison, which could kill game and fish without contaminating the flesh. The poison was processed from the ground seeds and mixed with white latex from the lianas. The important chemical is strophanthin glucoside, which has medicinal uses as a cardioactive agent, effective (like digitalis, extracted from foxgloves) in regulating heartbeat and circulation. It also has properties comparable to cortisone, and it was traditionally used as a snakebite antidote.

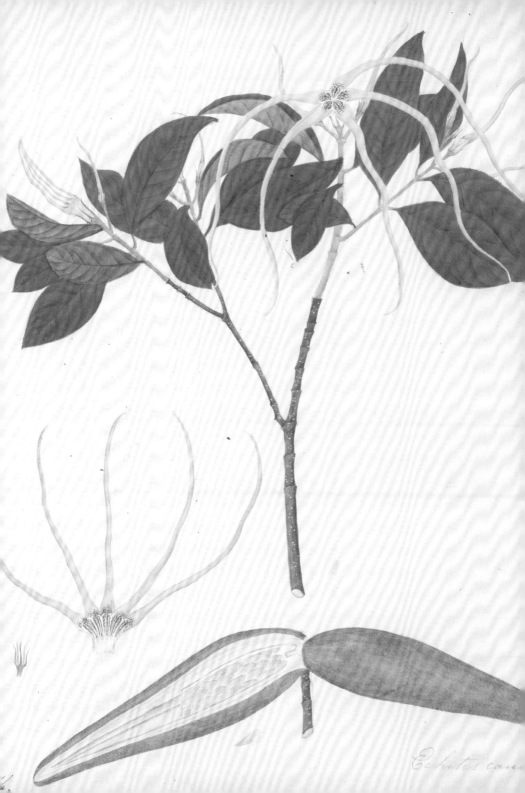

Echites can

SYZYGIUM

Cloves

The lucrative spice
trade of South East
Asia brought ships
from China and
Japan and across the Indian Ocean. Cloves, which are native to
the Maluku Islands, were among the most desirable, gathered
for their flavouring qualities when the aromatic flowers were
in bud. In medieval Europe they redeemed sour wine, earning
their name (from the Latin for 'nails') as they floated in the brew.
Cloves were also valued for relieving toothache, at a time when
such infections could kill. When the Dutch gained ascendancy
during the seventeenth century they guarded the trade jealously,
until 1795 when the French invasion of the Netherlands enabled
the English to break their monopoly. Clove and nutmeg plants
were transported to grow in other areas, including Penang, the
strategic island off Malaysia annexed in 1786. Here Sir Stamford
Raffles, arriving in 1805, saw spice plantations for the first
time. Later, when he was Governor of Sumatra, his residence
at Bencoolen (shown opposite) became the heart of his natural
history collections and a workshop for artists. Surrounding it were
plantations of pepper, nutmeg and cloves – which Lady Raffles
loved for 'the luxuriance of their foliage and the spicy fragrance
with which they perfume the air'.

TULIPA

Tulip

In the mountain valleys which
stretch for hundreds of miles
across Central Asia, tulips grow
wild where the trade routes
pass. Tulip bulbs were sold in
the markets and transported
to naturalise in orchards and
vineyards, producing all sorts
of variations along the way – *Tulipa schrenkii*, a major ancestor
of garden tulips, being one of the most diverse. The Mughal
emperors bore witness to the spread of tulips. Babur knew them
from the plains of Kabul where he started life as a warlord,
described those he saw when he conquered Samarkand, and had
tulips planted in the gardens he created in India. His grandson
Jahangir's favourite gardens were in Kashmir. 'In the soul-
enchanting spring', he wrote in 1620, 'the hills and plains are filled
with flowers, the courts and roofs are alight with the torches of
tulips' (*T. lanata* naturalises on roofs, including mosques). Persian
and Turkish poets, emulating Omar Khayyam and Hafiz, extolled
tulips: 'Perhaps the tulip knows the fickleness of fortune's smile
/ For on her stalk's green shaft she bears a wine cup through the
wilderness'. For the Turks, migrating westwards, tulips became
pre-eminent among garden flowers (see page 6), and a fashion for
elongated petals developed, matched with names like rose arrow,
pomegranate lance and vizier's finger.

Uvaria

Uvarias are large woody climbers in the tropical forests of Asia and Africa. Their stems can be woven like rattan and the fruit is edible – growing in clusters like elongated orange grapes (*uvaria* means grape in Latin). This, the most beautiful species (below), aptly named *Uvaria grandiflora*, grows throughout South East Asia including southern China. The large flowers are deep maroon, with a striking bulging centre, and are very attractive to butterflies, bees and sunbirds. In the Calcutta Botanic Garden, Nathaniel Wallich considered it 'one of the greatest ornaments this garden possesses'. In a Buddhist text from Thailand, illustrated here, uvaria appears at characteristic height above a monastery roof. Uvaria was illustrated for Sir Stamford Raffles's collection of natural history drawings by a Chinese artist working at his estate near Bencoolen in Sumatra, whose name has been recorded as Ah Kow.

Only his work remains from the original team called by Raffles 'my Chinese draughtsmen'. In 1824 Raffles lost almost everything at sea, an ever-present peril facing both living plant collections, their records and their owners.

Viburnum

The handsome puffs of white flowers which decorate this
Japanese woodblock paper are viburnums, enhanced by the Asian
swallowtail butterflies alighting among them (although viburnums
are not a natural host, because swallowtails prefer oranges).
Coloured, textured, decorative and folded papers have long been
a Japanese speciality. This style, using woodblock patterns,
was closely related to textile designs used for kimonos, often
featuring flowers, especially fruit blossoms, although it is rare to
see the naturalism which is in evidence here. The largest viburnum
flower is the Chinese snowball, *Viburnum macrocephalum*,
with profuse blooms emerging from apple-green buds; however,
the Japanese snowball *V. tomentosum* is hardier. (Snowball is a
European name; in the East they are called embroidered
balls.) Both were introduced into Europe by Robert Fortune,
who reached China as the treaty ports were opened after the
Opium War of 1840–42, and to obtain popular cultivars such as
viburnums he needed only to visit the plant nurseries of the treaty
ports. The fragrant viburnums, *V. fragrans* and *V. carlesii*, grow
further north in China, and did not reach Europe until the early
twentieth century.

نظامی بدو عالی آوازه باد
به بطنی جنین نام او وازه باد

برو باد و فرخنده جون نام او
ز آغاز او و تا انجام او

فرغ من تحریر هذا الکتاب بعون الملک الوهاب علی ید
العبد الفقیر المذنب شاه محمود النشابوری اثامی الکاتب
عفر ذنوبه و ستر عیوبه فی عشرین من شهر
فی الحجه سنه تسع و اربعین و تسعمائه
بدار السلطنه تبریز

VIOLA

Violet

In China and Japan, games which involved creating and quoting short poems were a pastime among the courtly and scholarly classes. They would admire and outdo each other, lubricating their efforts with rice wine, and on warm evenings by a stream they might set their verses adrift on little bamboo boats lit by candles. The poems would be linked in a thematic chain, for instance springtime and night, like this eighth-century Japanese verse: 'To the fields of spring / To pick violets I came— / I who in fondness / For those fields could not depart / But stayed and slept the night'. Haiku, with its seventeen syllables, is the shortest among traditional Japanese verse forms. It is associated above all with the seventeenth-century scholar Basho, who incorporated haiku into his accounts of travelling around Japan: 'Here in the mountain pass / Somehow they draw one's heart so / Violets in the grass'. Mughal poets were also inspired by violets, acknowledging the apparent humility of their delicately bending flower-stalks, but pleasurably suspicious of the scented charms beneath. 'The violet lies in an ambush of enchantment' wrote Shah Jehan's court poet; and for Jahangir, visiting his favourite Kashmir gardens in spring, 'The violet braided her locks, the buds tied a knot in the heart'.

Grapevine

The Mesopotamian Epic of Gilgamesh, compiled over 4,000 years ago, offered the first literary references to wine: after drinking seven goblets of wine, the hero is described as exultant, with a shining face. The twelfth-century *Rubaiyat* of Omar Khayyam ('Come fill the cup and in the fire of spring / Your winter garment of repentance fling') is a hymn to drinking, despite the strictures of Islam, and Sufi mystics went further, teaching that tipsiness brought the soul closer to the divine. From the ancient Near East viticulture spread both east and west. When the Mughal emperor Babur conquered northern India he planted vines and wrote: 'to have grapes growing in Hindustan filled my measure of content'. Also from the vineyards of Central Asia grape cultivars were introduced into China, offering an exclusive drink 'sweeter than wine made from cereals'. Chinese conquests during the Tang dynasty (618–907) gave China control of Xinjiang province on the Silk Road. Here, oases and sophisticated irrigation systems supported the vineyards of Turfan, on the edge of the Taklamakan desert, a phenomenon recorded by Marco Polo and many subsequent travellers.

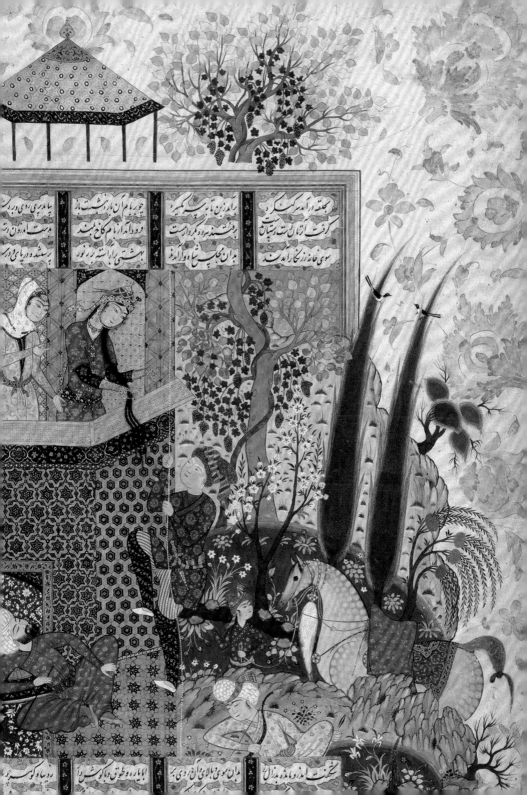

Wisteria

The greyer but more vigorous Chinese wisteria *W.sinensis* reached Europe early in the nineteenth century via Canton, followed by the lovelier violet-blue *W. floribunda* from Japan, introduced by Philipp Franz von Siebold in 1830. In Japan, wisteria (*fugi*) became a poetic metaphor for the elegance of a beautiful woman, or the purple of sorrowful love, reaching an apotheosis in the Kabuki theatre with the dance of the wisteria maiden, *fugi musume*. The set consists of a pine tree spread with wisteria, dangling its paper flowers like a massive purple curtain. Through this steps a male dancer with chalk-white face and layers of wisteria-patterned kimonos, carrying a branch of wisteria as large as himself. The maiden he impersonates is by turn coquettish and forlorn and – in the most skilful sequence of all – tipsy. In the *Tale of Genji* wisteria was the most significant of flowers, being the clan name, Fujiwara, of the two women the Prince loved most. For his future wife Murasaki (her name means 'little purple flower') he designed a garden, festooning the verandah and the walks with wisteria. But Genji's love poems never matched the passion of: 'This blue fire falling ... their honey tongues loll like a million bells that quiver and don't ring, /though the air all trembles and vibrates with them' (Sacheverell Sitwell).

LIST OF ILLUSTRATIONS

46–47 Bamboo and moon. Album of the Ten Bamboo Studio, c. 1643. Or.59.a.10.

48 *Bauhinia* (butterfly tree). *Qun fang no*, China, 19th/20th century. Or.13347 A f.29.

51 *Bombax ceiba*. *Qun fang no*, China, 19th/20th century. Or.13347 A f.3.

53 *Camellia japonica*, from a volume of coloured drawings, by native artists, of Chinese animals, birds, insects, fishes, reptiles, plants, etc., 18th century. Add. 15503 f.13.

54 The process of planting, growing and curing tea, 1808. Maps K.Top.116.19.2.d.

55 Tea plant, watercolour by a Chinese artist, c. 1800. NHD 54, Vol.3, f.32.

57 *Chaeonomeles japonica* (Japanese quince). *Siebold's Florilegium of Japanese Plants (Held in the Komarov Botanical Institute, Library of the Russian Academy of Sciences, St Petersburg)*, 1993–94. Orb 45.

58 *Chimonanthus praecox* (Chinese New Year Flower). *The Mustard Seed Garden Painting Manual*, compiled by Hu Zhengyan, c. 1679–1701. 15274.a.1.

61 *Chrysanthemum. Fusō hyakugikufu* [One Hundred Types of Japanese Chrysanthemum], compiled and illustrated by Hyakkikutei Sosen, 1736. 16111.c.3.

62–63 *Chrysanthemum grandiflorum. The Mustard Seed Garden Painting Manual*, compiled by Hu Zhengyan, c. 1679–1701. 15274.a.1.

64a *Citrus* (orange), watercolour by a Chinese artist, c. 1800. NHD 55 Vol.4, f.32.

64b *Citrus* (orange). *Baburnama* [Memoirs of Babur], Mughal, 1590–93. Or.3714, f.40.

67 *Citrus medica var. sarcodactylis* (Buddha's fingers). Album of the Ten Bamboo Studio, compiled by Hu Zhengyan, c. 1643 Or.59.a.10, f.6.

68 *Clematis florida. Qun fang no*, China,

19th/20th century. Or.13347 A f.21.

69 *Clematis. Siebold's Florilegium of Japanese Plants (Held in the Komarov Botanical Institute, Library of the Russian Academy of Sciences, St Petersburg)*, 1993–94. Orb 45, Vol.1a, f.24.

71 *Codonopsis lanceolata* (bellflower). *Ehon noyamagusa* [Picture-book of Wild Flowers], compiled and illustrated by Tachibana Yasukuni, 1883. 16033.a.15.

72 *Crocus sativus. Horæ Beatee Mariæ Virginis et Officia varia*, early 16th century. Egerton 1146, f.293.

75 *Curcuma longa* (turmeric). William Roxburgh, *Plants of the Coast of Coromandel*, 1795–1819. 10.Tab.34.

76 *Cymbidium virescens*. Album of the Ten Bamboo Studio, compiled by Hu Zhengyan, c. 1643. Or.59.a.10.

78 *Durio zibenthinus* (durian). Drawings made by Chinese artist at Bencoolen, Sumatra, for Sir Stamford Raffles, c. 1824. NHD 48 f.25.

81 *Erythrina* (coral tree), by a Chinese artist, c. 1800. NHD 52 Vol.3, f.36.

82 *Forsythia suspensa. Siebold's Florilegium of Japanese Plants (Held in the Komarov Botanical Institute, Library of the Russian Academy of Sciences, St Petersburg)*, 1993–94. Orb 45.

85 *Fritillaria imperialis* (crown imperial). Dara Shikoh Album, Mughal, c. 1633–42. Add. Or. 3129, f.62.

86 *Gardenia*, by a Chinese artist, c. 1800. NHD 52, Vol.1 f.3.

89 *Gloriosa superba*. Thomas Hardwicke, Collection of Indian paintings, 18th–19th century. Add. 11011, f.41.

90 Processing cotton from an Album of trades and occupations in Kashmir, a Kashmiri artist, c. 1850–60. Add.Or. 1660–1745, f.68.

91 *Gossypium indicum* (cotton). *Siebold's Florilegium of Japanese Plants (Held in the Komarov Botanical Institute, Library*

of the Russian Academy of Sciences, St Petersburg), 1993–94. Orb 45.

92 *Hemerocallis fulva* (orange day lily), by a Chinese artist, c. 1800. NHD 53/27.

93 *Hemerocallis flava* (yellow day lily). *Ehon noyamagusa* [Picture-book of Wild Flowers], compiled and illustrated by Tachibana Yasukuni, 1883. 16033.a.15.

94 *Hibiscus rosa-sinensis. Ehon noyamagusa* [Picture-book of Wild Flowers], compiled and illustrated by Tachibana Yasukuni, 1883. 16033.a.15.

97 *Hosta sieboldii* (plantain lily). *Siebold's Florilegium of Japanese Plants (Held in the Komarov Botanical Institute, Library of the Russian Academy of Sciences, St Petersburg)*, 1993–94. Orb 45.

98 *Hydrangea macrophylla. Ehon noyamagusa* [Picture-book of Wild Flowers], compiled and illustrated by Tachibana Yasukuni, 1883. 16033.a.15.

100 Indigo plant (*Indigofera tinctoria*), 1797–1805. NHD 19/107.

101 Dyeing with indigo. From an Album of trades and occupations in Kashmir, a Kashmiri artist, c. 1850–60. Add. Or. 1660-1745, f.55.

102 *Ipomoea tricolor* (morning glory). Drawings of plants collected in Japan by Philipp Franz von Siebold. Or.916, f.28.

104–5 *Ipomoea* (morning glory). *Shasei soka Moyo* [Japanese designs on botanical themes] compiled by Korin Furuya, 1907. ORB.30/132.

106 *Iris laevigata. Ehon noyamagusa* [Picture-book of Wild Flowers], compiled and illustrated by Tachibana Yasukuni, 1883. 16033.a.15.

107 *Iris germanica*. Dara Shikoh Album, Mughal, c. 1633–42. Add.Or.3129, f.41v.

108 A species of jasmine, drawing prepared in India for Marquess Wellesley, 1798–1805. NHD 15/78.

109 *Jasminum nudiflorum* (yellow winter jasmine). *Siebold's Florilegium of*

Japanese Plants *(Held in the Komarov Botanical Institute, Library of the Russian Academy of Sciences, St Petersburg)*, 1993–94. Orb 45.

110 *Kaempferia coronarium* syn. *Hedychium coronarium* (ginger lily), drawing prepared In India for Marquess Wellesley, 1798–1805. NHD 10, f.19.

112 Walled garden with red and white lilies. Poetical works of Khwaju of Karman, Persian, 1396. Add. 18113, f.18v.

113 *Lilium martagon* (Turk's cap lily). Dara Shikoh Album, Mughal, c. 1633–42. Add.Or.3129, f.61v.

115 *Litchi chinensis* (lychee). Album of the Ten Bamboo Studio, compiled by Hu Zhengyan, c. 1643. Or.59.a.10.

116 *Magnolia*, by a Chinese artist, c. 1800. NHD 56, Vol.2, f.24.

117 *Magnolia*, from a volume of coloured drawings, by native artists, of Chinese animals, birds, insects, fishes, reptiles, plants etc., 18th century. Add. 15503, f.110v.

119 *Malus micromalus* (Chinese crab apple). *Siebold's Florilegium of Japanese Plants (Held in the Komarov Botanical Institute, Library of the Russian Academy of Sciences, St Petersburg)*, 1993–94. Orb 45.

120 *Mangifera indica* (mango), drawing prepared In India for Marquess Wellesley, 1798–1805. NHD 12/80.

123 *Melastoma malabathricum*. From Penang, drawing prepared in India for Marquess Wellesley, 1798–1805. NHD 17/68.

124 *Morus alba* (mulberry, with silkworm moths and cocoons), drawing by a Chinese artist, c. 1806. NHD 43/13.

126 *Musa paradisiaca* (banana flower). Thomas Hardwicke, Collection of Indian flower paintings, 18th and 19th century. Add. 11011, f.46.

127 *Musa paradisiaca* (banana). The owner of the garden discovering maidens bathing in the pool, miniature from *Khamsa of Nizami*, Mughal, 1593–95. Or.12208, f.220.

128 *Narcissus tazetta*. Dara Shikoh Album, Mughal, c. 1633–42. Add. Or. 3129, f.42.

131 *Nelumbo nucifera* (lotus). Drawings of plants collected in Japan by Philipp Franz von Siebold. Or.916, f.70.

132 *Nelumbo* (lotus). Thai Buddhist manuscript, 18th century. Or.14027, f.66.

133a Harvesting the lotus root, from an Album of trades and occupations in Kashmir, a Kashmiri artist, c. 1850–60. Add. Or.1660-1745, f.17.

133b A lotus flower grows from Vishnu's navel upon which Brahma, the Creator of the Universe, is seated. From *The Bhagavatapurana* [Purana of the Blessed Lord], 1806. Or.13805, f.100.

134 *Nepenthes distillatoria* (pitcher plant), by a Chinese artist, c. 1800. NHD 56, Vol.1, f.4.

136 *Nerium oleander* (oleander). Drawings of plants collected in Japan by Philipp Franz von Siebold. Or.916, f.5.

137 Lady seated with oleander and parakeet. Deccani-style miniature, c. 1660. J.10.1.

138 *Dendrobium*, yellow-flowered epiphytic orchid growing on a mango tree. Bengal-style watercolour prepared In India for Marquess Wellesley, 1798–1805. NHD 13/85.

139 *Cypripedium japonicum* (slipper orchid). *Sōkarui hyakushu* [One Hundred Types of Plants]. Manuscript, early 19th century. Or.5450, f.195.

140 *Bletilla striata* (hyacinth orchid). Drawings of plants collected in Japan by Philipp Franz von Siebold. Or.916, f.99.

141 *Arachnis moschata* (spider orchid). 'Scorpion Orchid, Orchid of Indonesia', drawing made by a Chinese artist at Bencoolen, Sumatra, for Sir Stamford Raffles, c. 1824. NHD 48/16.

142 Sowing and harvesting of rice, from an Album of trades and occupations in Kashmir, a Kashmiri artist, c. 1850–60. Add.Or.1660-1745, f.82.

144 *Paeonia suffruticosa* (tree peony), by a Chinese artist, c. 1800. NHD 56 Vol.2, f.18.

145 *Paeonia suffruticosa* (tree peony). *Ehon noyamagusa* [Picture-book of Wild Flowers], compiled and illustrated by Tachibana Yasukuni, 1883. 16033.a.15.

146 *Panax ginseng* (ginseng). Chinese Materia Medica, compiled by Li Shizhen, 1603. 15251.e.2 f.4r.

148 *Papaver somniferum* (poppy). Arabic version of *De materia medica*, by Dioscorides, Baghdad, 1334. Or.3366, f.134.

149 *Papaver* (poppy). *Ehon noyamagusa* [Picture-book of Wild Flowers], compiled and illustrated by Tachibana Yasukuni, 1883. 16033.a.15.

150 *Paulownia tomentosa*. *Siebold's Florilegium of Japanese Plants (Held in the Komarov Botanical Institute, Library of the Russian Academy of Sciences, St Petersburg)*, 1993–94. Orb 45.

153 *Phoenix dactylifera* (palm trees). *Baburnama* [Memoirs of Babur], Mughal, 1590–93. Or.3714, f.402.

154 *Piper nigrum* (pepper). Medical history of E. Indian trees and plants, 17th century. Sloane 4013, f.7.

157 *Platycodon grandiflorus* (balloon flower). *Siebold's Florilegium of Japanese Plants (Held in the Komarov Botanical Institute, Library of the Russian Academy of Sciences, St. Petersburg)*, 1993–94. Orb 45.

158 Lady by pink blossom tree (almond or peach). Dara Shikoh Album, Mughal, c. 1633–42. Add.Or.3129, f.34.

159 Plum blossom. *Baihin* [Plum Products], illustrated by Matsuoka Joan. Late 19th-century edition of work originally published in 1758. ORB.30/8096.

160–61 Peaches. Album of the Ten Bamboo Studio, c. 1643. Or.59.a.10.

162 *Punica granatum* (pomegranate). Album of the Ten Bamboo Studio, compiled by Hu Zhengyan, c. 1643. Or.59.a.10.

163 *Punica granatum* (pomegranate), by a Chinese artist, c. 1800. NHD 56 Vol.4, f.47.

164 *Rhododendron*, by a Chinese artist, c. 1800. NHD 52/8.

165 *Rhododendron indicum*, a parent of modern cultivars. *Siebold's Florilegium of Japanese Plants (Held in the Komarov Botanical Institute, Library of the Russian Academy of Sciences, St Petersburg)*, 1993–94. Orb 45.

167 *Rhodomyrtus tomentosa*. *Siebold's Florilegium of Japanese Plants (Held in the Komarov Botanical Institute, Library of the Russian Academy of Sciences, St Petersburg)*, 1993–94. Orb 45.

168 *Rosa* (rose). *Ehon noyamagusa* [Picture-book of Wild Flowers], compiled and illustrated by Tachibana Yasukuni, 1883. 16033.a.15.

169 Yellow rose, by a Chinese artist c. 1800. NHD 56, Vol.3, f.31.

171 *Saccharum sinense* (sugar cane). William Roxburgh, *Plants of the Coast of Coromandel*, 1795–1819. 10.Tab.34, Vol.3, f.38.

172 *Salix babylonica* (willow). Decorated letter paper from the Ten Bamboo Studio, facsimile of the 1934 edition. Or.80.d.9.

175 *Strophanthus caudatus*, by a Chinese artist, c. 1800. NHD 56, Vol.4, f.38.

176 Raffles residence at Pematang Balam, Bencoolen, West Sumatra, surrounded by a clove plantation, watercolour, c. 1823. WD 2975.

177 *Syzygium aromaticum* (cloves). Drawing made by a Chinese artist at Bencoolen, for Sir Stamford Raffles, 1823–25. NHD 48/29.

178 *Tulipa lanata* (tulip) and pheasant, Dara Shikoh Album, Mughal, c. 1633–42. Or.3129, f.71v.

179 Tulips growing in an orchard, from *Saqinama* by Nur al-Din Muhammad Tahir Zuhuri, 1685. Or.338, f.110a.

180 *Uvaria*. Thai Buddhist manuscript, 19th century. Or.16552, f.9.

181 *Uvaria grandiflora*. Drawing made by a Chinese artist at Bencoolen, for Sir Stamford Raffles, 1823–25. NHD 48/2.

183 *Viburnum* (Chinese snowball, with yellow swallowtail butterflies). Olga Hirsch decorated papers. J.3409b.

184 *Viola persica* (violet). Persian miniature from the *Khamsa of Nizami*, Tabriz 1539–43. Or.2265, f.396.

185 White violet. *Siebold's Florilegium of Japanese Plants (Held in the Komarov Botanical Institute, Library of the Russian Academy of Sciences, St. Petersburg)*, 1993–94. Orb 45.

186 *Vitis vinifera* (grapevine) from a volume of coloured drawings, by native artists, of Chinese animals, birds, insects, fishes, reptiles, plants, etc., 18th century. Add. 15503, f.216.

187 Grapevine twisting up tree, from *Shahnama*, Persian, c. 1590–95. Add. 15503, f.2.

188 Cutting the wisteria. *Ise monogatari* [Tales of Ise], anonymous manuscript, Japan, 16th century. Or.904 Vol.3, episode 80.

Selected Further Reading

E. Brill (ed.), *Gardens in the Time of the Great Muslim Empires* (New York: Brill, 1994)

N. Cameron, *Barbarians and Mandarins: Western Travellers in China* (New York: Oxford University Press, 1970)

A. Coates, *Garden Flowers and their Histories* (London: Vista, 1956)

A. Coates, *Garden Shrubs and their Histories* (London: Vista, 1963)

A. Coates, *The Quest for Plants* (London: Studio Vista, 1969)

M. Conan (ed.), *Middle East Garden Traditions* (Dumbarton Oaks: Harvard University Press, 2007)

M. Campbell-Culver, *The Origin of Plants* (London: Headline, 2001)

S. Crowe, *The Gardens of Mughal India* (London: 1972)

S. Dalley, *The Mystery of the Hanging Garden of Babylon* (Oxford: Oxford University Press, 2013)

C. Fisher, *The Golden Age of Flowers* (London: British Library, 2011)

M. Gharipour, *Persian Gardens and Pavilions*, (New York: I. B. Tauris, 2013)

M. Keswick, *The Chinese Garden* (London: Frances Lincoln, 1978; revised 2003)

H. Li, *The Garden Flowers of China* (New York: Ronald Press, 1959)

E. MacDougall and R. Ettinghausen (eds), *Islamic Gardens* (Dumbarton Oaks: Harvard University Press, 1976)

E. Schafer, *The Golden Peaches of Samarkand: A Study of T'ang Exotics* (Berkeley: University of California Press, 1963)

N. Titley and F. Wood, *Oriental Gardens* (London: British Library, 1991)

P. Valder, *Gardens in China* (Portland: Florilegium, 2002)

J. Wescoat (ed.), *Mughal Gardens: Places, Representations and Prospects* (Dumbarton Oaks: Harvard University Press, 1996)

Sources of Quotations

Translations of Asian and Middle Eastern texts are reproduced, extracted or adapted from the following sources:

A. J. Arberry, *Fifty Poems of Hafiz* (Cambridge: Cambridge University Press, 1947): p. 178 'Perhaps the tulip …'.

A. Beveridge (transl.), *Baburnama (Memoirs of Babur)* (London: Luzac, 1921, revised 1970): p. 65 'In the southwest part …'; p. 136 'Those of Gwalior are deep red …'; p. 152 'No hilarity was felt …'; p. 186 'to have grapes growing …'.

H. Beveridge (ed.) and A. Rogers (transl.), *Tuzuk-i-Jahangiri, or Memoirs of Jahangir* (New Delhi: Munshiram Manoharlal, 1978): p. 18 'Kashmir…'; p. 178 'In the soul-enchanting spring …'; p. 185 'The violet braided …'.

C. Birch (ed.), *Anthology of Chinese Literature* (London: Penguin, 1965): p. 8 'Have you not heard of the Shanglin …'.

E. A. Cranston (transl.), *A Waka Anthology* Vol. 1 (Stanford: Stanford University Press, 1993): p. 185 'To the fields …'.

H. G. Henderson, *Introduction to Haiku: An Anthology of Poems and Poets from Basho to Shiki* (New York: Doubleday, 1958): p. 103 'A morning glory …'.

H. B. Joly (transl.), *The Dream of the Red Chamber* (Hong Kong: Kelly & Walsh, 1892): p. 23 'The garden, however lovely …'.

D. L. Keenan, *Yun Chi: Shadows in a Chinese Landscape* (London: Sharpe, 1999): p. 95 'I lament …'; p. 136 'In three places …'.

D. Keene (ed.), *Anthology of Japanese Literature* (London: Penguin, 1968): p. 20 'It looked as if …'.

R. Latham (ed.), *The Travels of Marco Polo* (London: Penguin, 1958): p. 9 'Wherever the Khan …'; p. 144 'Roses as large …'.

J. Liu (transl.), *The Poetry of Li Shang-yin* (Chicago, London: University of Chicago Press, 1969): p. 77 'The chamber with an orchid-fragrant…'; p. 144 'I wish to write on petals …'.

P. E. Losensky, 'The Palace of Praise and the Melons of Time: Descriptive Patterns in 'Abdī Bayk Sīrazī's *Garden of Eden*', *Eurasian Studies* 2 (2003): p. 16 'Varieties of fruits …'.

G. Maine (ed.), *Rubáiyát of Omar Khayyám Rendered into English Verse by*

Edward Fitzgerald (London: Collins, 1947): p. 186 'Come fill the cup …'.

I. Morris (ed. and transl.), *The Pillow Book of Sei Shonagon* (London: Oxford University Press, 1967): p. 23 'A large garden covered in snow …' and other passages; p. 107 'There is not a place …'.

S. Obata, *The Works of Li Po* (New York: E. P. Dutton, 1922): p. 144 'The glory of trailing …'.

R. Payne (ed.), *The White Pony: An Anthology of Chinese Poetry* (New York, London: Theodore Brun, 1949): p. 22 'Spring comes late …' adapted from 'Buying Flowers'; p. 60 'I am thinner than a yellow flower'; p. 60 'The autumn chrysanthemums …'; p. 92 'How shall I get the herb …'.

G. W. Robinson (ed. and transl.), *Poems of Wang Wei* (London: Penguin, 1973): p. 77 'Lovely the landscape …'; p. 117 'Lotus flowers …'.

E. H. Schafer, *The Golden Peaches of Samarkand* (Berkeley: University of California Press, 1963): p. 73 'From India, with purple …'; p. 100 'The mountain named India …'; p. 114 'A thousand gates …'.

A. Schimmel, *A Two-Coloured Brocade: The Imagery of Persian Poetry* (Chapel Hill: University of North Carolina Press, 1992): p. 169 'How long is the life …?'

A. Waley (transl.), *The Tale of Genji* (New York: Modern Library, 1966): p. 103 'can it be that the morning glory …'.

J. L. Wescoat and J. Wolschke-Bulmahn (eds), *Mughal Gardens: Sources, Places, Representations and Prospects* (Dumbarton Oaks: Harvard University Press, 1996): p. 185 'The violet lies …'.

J. D. Yohannan (ed.), *A Treasury of Asian Literature* (New York: Day, 1956): p. 169 'The red rose …'.

N. Yuasa (transl.), *Basho: The Narrow Road to the Deep North, and Other Travel Sketches* (London: Penguin, 1966): p. 20 'From the hairy …'; p. 126 'Wind-tossed banana leaves …'; p. 159 'Under a cherry tree …'; p. 173 'Spreading its shade …'; p. 185 'Here in the mountain pass …'.

INDEX